THE AIR WAR
IN PAINTINGS

Published by IWM, Lambeth Road, London SE1 6HZ
iwm.org.uk

ISBN 978-1-912423-75-0

A catalogue record for this book is available from the British Library

Printed and bound in Italy by Printer Trento
Colour reproduction by DL Imaging

All images © IWM unless otherwise stated
Front cover: ART LD 1550
Backcover: ART LD 2123

10 9 8 7 6 5 4 3 2 1

THE AIR WAR
IN PAINTINGS

Suzanne Bardgett

When the War came, suddenly the sky was upon us all like a huge hawk hovering, threatening.

Paul Nash

Contents

Introduction

In December 1939 the BBC broadcast an announcement seeking artists to record aspects of the Second World War. It was going to be a difficult time for artists and the idea of depicting the war for posterity was appealing. Many of those hearing the broadcast would have known of the earlier scheme that had operated during the First World War. Most would have seen the paintings that had resulted – shown at the Royal Academy in 1919, and since then shown in rotation in the art galleries of the Imperial War Museum (IWM). It was perhaps not surprising that 775 applications were submitted to the newly formed War Artists Advisory Committee (WAAC).

The IWM's 'air war paintings' have been exhibited from time to time but rarely, if ever, as one large group, for the preference has usually been to showcase the work of their best-known creators – in particular Paul Nash, Eric Ravilious and Eric Kennington. Seeing a good proportion of them in one place allows us to see how a much larger group of artists documented numerous aspects of the vast effort to build Britain's air capacity, an effort which had profound effects on towns and villages across the UK and impacted thousands of people's lives. From an art historical perspective, the works, many rarely shown before, add to our understanding of government patronage of mid-twentieth-century British art.

The WAAC was a small committee within the Ministry of Information (MOI), headquartered in Senate House, Bloomsbury, and presided over by the energetic and well-connected Sir Kenneth Clark, Director of the National Gallery. Clark had a clear vision of what he wanted from the scheme: 'real records and not set pieces cooked up in the artist's studio,' as he explained in a letter to his friend Frank Pick, whose own celebrated project had been to create the visual identity of London Transport. It was inevitable of course that many of the paintings were done in studios, but they were based on studies and photographs of actual places, people and events, and the artists selected to undertake the work were carefully chosen. As Clark told Pick, his employment of 'imaginative artists' was the chief reason for the scheme's success.

Clark chaired the WAAC's fortnightly meetings and did much work behind the scenes; he was on personal terms, for example, with Paul Nash, Eric Kennington, Mervyn Peake and Laura Knight. He was supported by the Committee's Secretary, E M O'R Dickey, who stood down in July 1942, to be succeeded in turn by the artist Elmslie Owen and the publisher Eric Gregory. It is from correspondence

'Outsize aircraft, outsize hangar': photograph taken c.1942 by an RAF photographer working for the MOI. Paul Nash called the MOI's Photograph Division 'a mine of inexhaustible yield and infinite variety'. **CH 6835**

with Dickey that we shall hear most in this book, for the majority of the artists received their initial commissions during his tenure. Dickey had taught art at Oundle School and Armstrong College in Newcastle, and in 1931 had published a beginners' picture book of British art. He got on well with Clark, serviced the WAAC with diligence and ensured that the Committee's vision for a body of work that documented the war was matched by an intake of well-chosen works, which were then shown in a series of exhibitions at the National Gallery and later toured to galleries around the country. Irene Neville, the Committee's administrator, took minutes, assisted the artists with access to subjects and saw that the paintings submitted were presented at meetings and, if approved, sent to Alfred Stiles & Sons, the Hammersmith-based framemakers, who had the contract for all the WAAC's output. Irene Neville did much else behind the scenes, ensuring for example that photographs of portraits of airmen who had lost their lives were sent to their bereaved relatives.

The artists were in essence part of a propaganda effort, contributing to the notion the wartime government wanted to foster – that of an island nation pitted against the enemy, of young men engaged in extraordinary acts of courage to save their country. This though was tempered by the WAAC's determination to avoid militaristic paintings, but rather to emphasise the enduring qualities of British life that would ultimately triumph over Germany. This was at the core of the MOI's thinking, and the works in this book underline that slant. 'Action paintings' were not wanted or, when they were, artists were encouraged to apply a thoughtful approach. Interestingly, Eric Kennington's portraits – the product of intense personal zeal – were felt by some critics to be bombastic and out of tune with the times.

The scheme was also intended to introduce an appreciation of art to a wider public. We get some notion of Clark's thinking in Jill Craigie's 1944 film, *Out of Chaos*,

about the official war artists, in which Clark says that he wants the Committee's works to convey what the war 'felt like'. In the film, the *Manchester Guardian* art critic Eric Newton talks to members of the public about the war art on display in the National Gallery, telling them firmly that art is for everyone, not just for the elite. The film's tone seems patronising today, but its intentions were sincere, reflecting a conviction that culture had a role to play in the war effort and in the rebuilding that would eventually come. 'The original artist is always a generation ahead of the public,' Newton patiently explains, using examples of press reactions to John Constable and J M W Turner's works to show that 'the shock of the new' is an eternal topic. Craigie's *Out of Chaos* underlines the utopian vision that Clark and his colleagues drove forward through their work.

In terms of status, the WAAC was dwarfed by the might of the Air Ministry's Public Relations Division. The knowledge that the outcome of the war depended, at least initially, on the success of the RAF meant that the Air Ministry had an exalted position in government circles. Its importance was palpable in its very presence in London, where large and impressive offices on Kingsway, Berkeley Square and King Charles Street gave a sense of almost infinite power. The Air Ministry, like the other services, was represented on the WAAC. It was not surprising that when disagreements arose between the WAAC and its Air Ministry representative, Director of Public Relations Air Commodore Harald Peake, the WAAC often lost the battle. Harald Peake was himself an amateur artist and had pronounced, somewhat conservative views on what kind of art should be commissioned as a permanent record of the RAF's endeavours, and this would have some trying ramifications for Clark and Dickey. Tensions were eventually resolved when Peake was replaced by his deputy, the aristocratic, but seemingly more amenable, Group Captain Lord Willoughby de Broke.

Interior of a bomber
aircraft with the captain
and bomb aimer, c.1941.
CH 3880

A watch office at Snaith, Yorkshire, where Halifax bombers are being guided back after a night raid on Nuremberg. **CH 18743**

Air Ministry Public Relations had well-honed procedures in place to ensure that there was a steady stream of stories for issue to the press. A team of popular authors and journalists – colloquially known as 'Writers Command' – regularly interviewed aircrew about their experiences, writing them up as communiques. There was also a very active photographic unit which produced thousands of images of air activity. A film section supplied commercial companies with footage of combat, and oversaw the RAF Film Unit,

which produced a steady output of films, such as the very successful *Target for Tonight*, shot at RAF Mildenhall and Bomber Command headquarters at High Wycombe in 1941. In short, the artistic output on the air war was just one very small element in a much larger enterprise.

Aviation had been a major obsession with the public during the 1920s and 1930s, with air shows, pageants and new flying records prominent in the news. The prominence

of the RAF in popular culture attached a distinct glamour to the service, and this admiration was compounded by it being the most visibly innovative of the three services. Anyone given access to this world experienced the heady atmosphere surrounding fighter pilots during and after the Battle of Britain, when the nation's attention and gratitude to these young men was so deep, the summer of 1940 quickly becoming mythologised as Britain's 'finest hour'. The courage of airmen was a constant theme in every form of news reporting and spending time on a fighter station could not fail to leave its mark.

Group Captain Peter Townsend's words give a sense of the mood of the time:

> We sparred above the clouds; or we would
> fly together straight at a cliff-face, daring one
> another to be the last to pull clear. Ignoring
> the regulations we looped and rolled in
> formation at ground-level. We borrowed
> two Spitfires from 152 Squadron... In tight
> formation we dived those Spitfires low over
> 152's hangar, pulled them up into a loop, dived
> again, rolled and gambolled. It looked like
> terrible exhibitionism, but was really only an
> expression of *joie de vivre*, which the whole
> squadron shared. No one, we believed, least of
> all the Germans, could ever beat us.

The air war transformed the landscape as 'gigantic hangars rose from the placid fields,' to quote Hector Bolitho, one of the Air Ministry's public relations officers and an eloquent memoirist. British rural society was initially hostile to this transformation due to the deafening noise of aircraft and the hot-headed antics of young men, but their frustration, as recorded by Bolitho, soon changed to intense admiration. The artists admitted into this world knew they were recording history in the making. The allure of the air war made

RAF bomber crew being debriefed on their return from a night raid over Germany, 1941. Photograph by Cecil Beaton. **D 4750**

for a spate of books, plays and films which in turn influenced and nurtured the artists' work. H E Bates's stories published initially in the *News Chronicle* and subsequently as a book, *How Sleep the Brave* (1943), Terence Rattigan's play *Flare Path*, and Richard Hillary's memoir *The Last Enemy* (both 1942) were just some of the outpourings that fed public imagination about the RAF and would have – consciously or subconsciously – seeped into the artists' work.

Prior to the war, nearly all the artists in this book had received art school training – many at the Slade School of Art, which had seen a veritable blossoming of talent in the early years of the century, or the Royal College of Art where there was an enlightened and forward-

looking approach to applied art. The artists were usually allocated topics considered apt for their skills, but the Committee knew the importance of giving artists some licence and was receptive to their own suggestions. Leslie Cole – familiar from boyhood with Swindon's engineering workshops – found inspiration in the manufacturing of aircraft and the bombs they would carry on their missions. Elsie Hewland was aware of the frenzied activity taking place at the Hawker Company's airfield at Langley, Slough, just a few miles south of her Buckinghamshire village, where fighter aircraft were being tested on a double-length runway. She also had ambitions to paint at an American base. Alan Sorrell, who enlisted in the RAF, and later worked at the Air Ministry, saw the potential of the hutted encampments he came across at aerodromes across the UK, which offered 'an enormous mass of unheroic but exciting stuff'.

The 'exciting stuff' was of course wreaking appalling suffering on the civilian population of Germany, but there was little sympathy in 1940 for their plight. The RAF were, after all, defending the UK against the Luftwaffe's attacks on its cities, where the destruction had been intense. 'Buildings we had known for twenty years were no more than cracked walls, with all the life that once breathed within them collapsed into rubble,' recalled Hector Bolitho. Most of the artists were in some way affected by the Luftwaffe's air raids. Leslie Cole saw the city of Hull severely damaged by intensive bombing. Paul Nash and Keith Henderson had some of their work destroyed. Gertrude Thomson, wife of the artist A R Thomson, wrote after they had fled their stricken Chelsea home: 'We are sitting here in an empty cottage with a camp bed and a mattress, glad to be alive and together'. Even those with strongly internationalist, pacifist leanings depicted what they saw as Britain fighting back. There was elation that the country was expanding its air capacity at a time of national crisis.

The air war transformed both towns and countryside. By 1945 there were 720 airfields, where in 1935 there had been just 150 – an engineering effort comparable, as Secretary of State for Air Sir Archibald Sinclair told Parliament, to 'a road from London to Peking'. Car factories were turned over to aircraft production on a colossal scale, giving employment and temporary prosperity to thousands of people, especially women. The fenced off 'no-go' areas, and the constant drone of aircraft overhead, impacted public consciousness, as did the daily reporting of the air war on the wireless and in newsreels. The obvious threat from the Luftwaffe to the south and east of England meant that training and much other activity was moved to the north-west. The seaside resort of Blackpool filled up with RAF personnel, and Prestwick on the west coast of Scotland became a reception point for aircraft and personnel arriving from the US and Canada.

This book focuses mainly on the art produced on the air war as it was experienced in the UK. Some of the artists were sent overseas to paint RAF activity – notably Leslie Cole who went to Malta – but the coverage of other theatres is relatively slight, whereas the artistic record of air activity in the UK is thorough and offers a unique and distinctive story. The fact that so much of the air war was played out in the English countryside gave the artists scope to practise what many excelled at: the celebration of rural England. There had been a large number of books on this theme published in the 1930s, including a series of Shell Guides to different counties and regions, illustrated by John Piper and John and Paul Nash, among others. With the outbreak of war, nostalgic views of rural England became a key component in the MOI's propaganda thinking; officials were aware that the notion of the landscape and its idyllic ways of life being under threat could underline the values Britain was fighting for. The artists, writers, filmmakers and photographers shepherded to airfields by the Air Ministry

Aircrew in the lounge at Prestwick airport on the west coast of Scotland. **CH 14363**

experienced the intoxication of dew-filled mornings, or the silence of the night being broken by the drone of returning aircraft, and fed this into their reportage. By conversing with aircrew, they would have learned what it was like to look down on a landscape that they were helping to defend. 'We were somehow certain that we could not lose,' Peter Townsend later recalled. 'I think it had something to do with England. Miles up in the sky we fighter pilots could see more of England than any other of England's defenders had ever seen before. Beneath us stretched our beloved country, with its green hills and valleys, lush pastures and villages clustering round an ancient church. Yes, it was a help to have England there below.'

This appreciation of Britain's landscape was allied to the

neo-romantic movement. The term was first used by the writer Raymond Mortimer in 1942 and has come to rather loosely encompass the group of artists who shared an impulse to portray the essence of the British countryside. Graham Sutherland, John Piper, Paul Nash, Keith Vaughan, Edward Bawden and Alan Sorrell are among those to whom the term has been applied and, although they each had their distinctive styles, they shared a desire to portray a romanticised notion of rural England – an impulse reflected also in the literature of the time. The presence of so many airfields and other military establishments stimulated neo-romantic creativity. Where in the 1930s artists expressed nostalgia for an already-changing countryside, in the 1940s the same artists found poetic responses to the barbed wire, control towers and runways that suddenly appeared in the place of fields and farms.

IWM holds the correspondence between the WAAC and the artists from whom works were commissioned or purchased. Although mainly concerned simply with commissions, deadlines and payments, the letters also reveal much about the artists' private anxieties, their ambitions and their responses to the conflict. Some, such as the Quaker-raised Richard Eurich, wanted no active part in the war, although he was grateful for the opportunities it gave him. Paul Nash, despite the pacifist message of his First World War paintings, now embraced the new struggle: 'I may as well confess that my dearest wish is to contribute something useful to the RAF by one means or another.' He came to know some of the airmen serving close to where he lived in Oxford, used their descriptions to inform his paintings and was pleased that they – unlike some of their superiors at the Air Ministry – seemed to appreciate what he was trying to achieve with his art. He was desperate to be taken up in an aeroplane by the pilots he met, but the Air Ministry were reluctant to give permission and he never got the chance to fly, much to his regret. At RAF Leuchars, near St Andrews in

Scotland, a pilot watched Keith Henderson at work and asked him how he 'began a painting'. The same pilot then took him up for a spin and for a few hair-raising minutes left Henderson at the controls. Henderson, who wrote a diary of his time at Leuchars for the magazine *The Listener*, described taking his paints on a flight, the palette being handed round the cockpit and the priceless clumps of paint getting daubed all over the crew.

The artists were issued with passes to allow access to places that were usually out of bounds, but even so, efforts to overcome disbelieving officials – particularly at factories – are a constant theme in the correspondence. Concerns over the safe transportation of the artists' paintings also feature frequently. Those within reach of London would leave their parcelled-up canvases at a designated door at the side of Senate House. Others had to trust their works to the railways.

Competition for commissions from the WAAC was fierce. Artists with established reputations, or who were friends of Clark or Dickey, had an obvious advantage. Paul and John Nash both found work readily, although Paul Nash's situation became difficult on account of Air Commodore Peake's dislike of his too imaginative work. Laura Knight was another who had no difficulty obtaining work. Others though struggled, sometimes writing repeatedly to the WAAC and sending in works which were rejected one after another. David Bomberg had his appeals for work turned down time after time until, eventually, the Committee capitulated and sent him to cover an underground bomb store – an unpromising subject which Bomberg made his own.

More of a mystery hangs over the writer and illustrator Mervyn Peake, who, despite Clark's clear curiosity towards his work, and an initial payment for a series of drawings, failed to get further work from the WAAC until midway through the war. Trapped, as he saw it, in an

anti-aircraft battery near Dartford, Peake sent Clark a detailed account of a painting – 'Barrack Room Scene' – which the two men had evidently discussed. Clark (who knew Peake's reputation as a visionary writer and illustrator) sent requests to his commanding officer that he be given time off to paint, but it was not until 1943 that Peake got a formal WAAC commission, tackling first a glass-blowing factory, and the following year a bomber crew being debriefed after their mission over Germany.

In a few instances, the WAAC found themselves helpless in the face of artists who had their own connections. William Rothenstein, former Principal of the Royal College of Art, got himself invited to airfields where other artists were already at work, making himself unpopular with the Committee. Eric Kennington was another who knew his reputation could open doors and went his own way.

'People are killed every day,' wrote Hector Bolitho, 'I am a bit numb about it all now... I've lost so many friends.' The high level of losses was something those in close proximity to the air war soon came to appreciate. When Rothenstein was put up in an absent airman's room, he noted its contents: 'some cheap novels, a book or two connected with flying, photographs of parents, of a sweetheart, and a reminder of what must ever be deep down in their consciousness, an envelope containing a will'. Rothenstein learned again and again that young men whom he had painted had been shot down. 'Today I read in *The Times* of yet another of my sitters killed,' he wrote to Dickey, 'the 3rd within a fortnight.' Tom Gourdie, at 27 one of the youngest artists to contribute to the scheme, depicted a scene in early 1945 with a terrible aftermath: the airmen he sketched, about to take off in their Beaufighter, never returned.

There were many omissions in what was commissioned by the WAAC – topics which were physically impossible to cover, or off-limits for reasons of security or morale.

Bombs being stacked and later towed away from RAF Fauld in Staffordshire, the bomb store where David Bombergwas sent to paint.
CH 3043 and **HU 93007**

The MOI supplied Paul Nash with a constant stream of photographs of air activity. This photograph, of contrails (condensation trails) left by British and German aircraft high up in the sky, was taken on 18 September 1940 by Captain Len Puttnam, an official photographer from the War Office. **H 4219**

We are rarely shown the tremendous tension among the air crew who, night after night, set off to bomb Germany, knowing that their chances of returning safely were slim. Towards the end of the war, there was greater public recognition of the toll the war had taken on airmen's mental health. Guy Gibson in his book *Enemy Coast Ahead* (1946) described having nightmares and outbursts because of the extreme pressure. 'If ever there was such a thing as a war of nerves,' he wrote, 'then some of us in 83 Squadron were certainly beginning to get affected.'

Airmen who returned with severe burns, the discovery in dinghies of crew who had not survived at sea, these were of course not recorded, neither by the artists nor the official photographers and film cameramen. The

public, though, could well imagine the desperation of crews awaiting rescue: one of H E Bates's stories was an account of one such agonising wait. Rothenstein mentions seeing 'hearses, bedecked with flowers from grieving relatives, mingled with tractors pulling their loads of death' – a subject that would have been fully off-limits. We also see little of the ground staff or mechanics who serviced the aircraft, labouring for long hours with rudimentary accommodation. The RAF liked to think it was egalitarian and strove to project this image, but in reality it remained stratified and class-conscious. Although the WAAC tried to include portraits of lower-ranking servicemen and women in its output, the balance did not reflect reality. The enormous numbers of women who served in the Women's Auxiliary Air Force (WAAF) are represented to some degree, but there could have been much more representation of this massive force.

Black servicemen are almost entirely absent from the record. A R Thomson was commissioned to make six portraits of West Indian airmen, but I have only been able to locate one. Attitudes to young men who volunteered from the West Indies and Africa varied widely. From *The Eighth Passenger* (1969), Miles Tripp's account of the bomber crew he served with, we know that their Jamaican rear-gunner, Harry McCalla, was treated as their equal. But there was also prejudice and suspicion. Attitudes to Black servicemen were often condescending, and there could be greater prejudice against volunteers from Africa, whom some officials believed were less well educated than those from the West Indies. Towards the end of the war, there was a debate about the continuing intake of non-European volunteers into the RAF – an ugly and ungrateful episode in view of the contribution that had been made.

Thousands of RAF crew were taken prisoner after baling out, spending the rest of the war in German prisoner of war camps and their experience could not, for obvious reasons, be covered by the WAAC artists, although the last portrait in the book gives some idea of the impact of that experience. The airmen and women of the United States Army Air Forces (USAAF), whose intervention was so crucial to the war, were not among the subjects the artists were sent to paint, although there was some coverage of the aircraft supplied under the American Lend-Lease scheme.

The paintings in this book are a limited record, therefore, but one that takes the viewer directly to the airfields where so much action was taking place, as well as into the factories, camouflage and training facilities. Much of the art produced celebrated the work that ordinary people were contributing to the war effort, and this underlined the WAAC's desire to present an image of a war that relied on the efforts of everyone.

The artworks depicting the air war had a different impact from the newsreels of the day with their urgent, stirring scenes: a softer, less bombastic representation which must have been welcomed by the thousands of families bereaved by the conflict. They had a propagandist purpose, yet, as Ernest Newton was at pains to point out in the catalogue of a 1942 National Gallery exhibition, 'the age of heroics is over'. Government officials, sometimes slow to appreciate the value of the war artists scheme, were ordered, or persuaded, to open doors and gates that would otherwise have been firmly closed. The RAF historians chronicling the Second World War in the 1950s were upfront about just how much of the war effort had been improvised, and just how costly had been the lessons learned. The artists featured in this book saw all this at close hand, and created images that were sometimes awe-inspiring, but more often spoke simply of human effort in demanding, remorseless times.

Select Chronology

February 1940
The WAAC draws up its shortlist of artists to cover the war

Keith Henderson and Paul Nash are appointed as official war artists to specifically cover air subjects

March 1940
The Directorate of Publicity is set up at the Air Ministry

12 May 1940
Alfred Duff Cooper becomes Minister of Information

14 May 1940
Lord Beaverbrook is appointed Minister of Aircraft Production

26 May 1940
Allied troops begin to be evacuated from Dunkirk and other French ports, with 193,000 British troops evacuated by 4 June, with them several war artists

13 June 1940
Harry Watt's film *Squadron 992* about barrage balloons is released

July–September 1940
Daylight attacks by the Luftwaffe against shipping, ports and airfields are countered by the RAF, in what becomes known as the Battle of Britain

July 1940
First exhibition of WAAC paintings at the National Gallery

7 September 1940
Start of the Blitz on London and other British cities, which lasts until May 1941

May 1941
The National Gallery holds a further exhibition of WAAC paintings

20 July 1941
Brendan Bracken becomes Minister of Information

25 July 1941
Harry Watt's film *Target for Tonight* is released, Kenneth Clark noting that it provided 'excellent subjects for paintings'

August 1941
107 RAF bomber aircraft are lost in just 18 nights

September 1941
Winston Churchill instructs a drastic increase in bomber production

November 1941
In view of the losses of aircraft and crew, the Air Ministry demands a drastic curtailment of sorties, especially in bad weather

30–31 May 1942
The first 'thousand-bomber raid' on Cologne, Germany; the following month saw similar raids on Essen and Bremen

July 1942
E M O'R Dickey resigns as Secretary of the WAAC and is succeeded by the artist and teacher George Elmslie Owen

4 July 1942
First USAAF bombing missions over Europe begin

13 August 1942
Terence Rattigan's play *Flare Path*, set on a bomber base, opens to acclaim at the Apollo Theatre and runs for 18 months

2 September 1942
Eric Ravilious is killed in a rescue mission off the Icelandic coast

22 November 1942
Stafford Cripps becomes Minister of Aircraft Production

6 January 1943
BBC journalist Richard Dimbleby witnesses a bombing raid over Germany

16–17 May 1943
The 'Dambusters Raid' takes place on the Ruhr Valley in Germany

July 1943
The publisher Eric Gregory succeeds Elmslie Owen as Secretary to the WAAC

18 February 1944
RAF bombers carry out the Amiens raid in an effort to release prisoners of war

24–25 March 1944
'The Great Escape' from Stalag Luft III, following which 50 Allied airmen are shot in retribution

6 June 1944
The RAF and airborne forces play a major part in D-Day

December 1944
Out of Chaos, Jill Craigie's film about the war art commissioned by the WAAC, is released

December 1944
Guy Gibson's book *Enemy Coast Ahead* is serialised in the *Sunday Express*

14 February 1945
William Rothenstein dies

1 October 1945
The film *Journey Together*, the work of the RAF Film Production Unit, is released emphasising the importance of teamwork within a bomber crew

11 July 1946
Paul Nash dies

Raymond McGrath

Training – Aircraft under Construction

(1940)

Watercolour, 38 x 55.8 cm
ART LD 65

Before the War Artists Advisory Committee (WAAC) had even drawn up its shortlist of war artists, they were approached by Raymond McGrath, the acclaimed Australian modernist architect and interior designer. McGrath was famous for his remodelling of 'Finella', a house in Cambridge (1929), contributing to the design of the BBC's Broadcasting House (1932), and conceiving the sophisticated interior of the Fairey Atalanta flying boat that served Imperial Airways' African and Indian routes during the mid-1930s. Two books – *Twentieth Century Houses* (1934) and *Glass in Architecture and Decoration* (1937) – gave added gloss to McGrath's reputation.

Seeing the opportunity that the sleek lines of aircraft offered, McGrath proposed to the WAAC that he write a popular account of aircraft production, something he had already floated with his publishers Faber & Faber. McGrath did not hesitate to pull strings, arranging for both the artist John Piper and Geoffrey Webb, Slade Professor of Fine Art, to write to Kenneth Clark endorsing the idea. The book was not viable at the time, but it was agreed that McGrath should be commissioned to draw and paint at a series of aircraft factories.

Raymond McGrath

Fitters Working on a Spitfire

(1940)

Watercolour, 37.9 x 55.7 cm
ART LD 142

McGrath was impatient to start work as he was about to take up a new position as Senior Architect in the Office of Public Works in Dublin. He set himself a punishing schedule, visiting the following factories: Vickers-Armstrongs at Weybridge; Armstrong Whitworth at Coventry; Short Brothers at Rochester; Phillips & Powis at Reading; Rolls-Royce at Derby; another Vickers-Armstrongs at Southampton, and the Bristol Aeroplane Company. He wrote to E M O'R Dickey complaining of having to give 'endless explanations to gatekeepers and watchmen' as to what he was doing. 'It would be very useful therefore if I could have some fairly impressive looking permit to assure such people of my credentials.'

Initially commissioned to produce twelve drawings, McGrath persuaded the Committee to pay for four more to complete the series.

John Armstrong
Building Planes

(1940)

Gouache on paper, 37.1 x 54.2 cm
ART LD 6390

Under the piercing glare of industrial lamps, a team of agile, faceless workers assemble aircraft fuselages, which are resting on 'jigs' or wooden stands. John Armstrong gave the Committee an unusually robotic rendition of aircraft manufacturing.

Armstrong had served in the First World War and then gone on to become a theatre designer, and to create posters for Shell and the General Post Office. In 1938 he had visited Rome and produced a surrealist painting, *Pro Patria*, a disparaging judgement of Benito Mussolini's regime, which was shown at the progressive Lefevre Gallery and, many years later, acquired by the IWM.

Armstrong told the WAAC that he was 'ready to go anywhere in the country at the request of the Ministry to paint the results of air raids if they occur' and made a number of paintings of war-damaged houses and churches. Efforts to give Armstrong access to aircraft production were at first hindered by suspicion and obstruction, and he was asked to make do with photographs and film for visual reference, but eventually given access to this Vickers-Armstrong factory at Weybridge in Surrey.

Barnett Freedman
*Aircraft Runway in Course of Construction at Thélus,
near Arras, May 1940*

(1940)

Oil on canvas, 58.1 x 90.1 cm
ART LD 261

Barnett Freedman, a successful book illustrator, was one of four artists sent to France with the British Expeditionary Force, the others being Edward Ardizzone, Edward Bawden and Reginald Eves. Freedman's painting captures the effort involved in constructing a concrete runway – one of five built in France in the spring of 1940.

Freedman informed Dickey that around 1,000 workmen were employed on the task, working under the direction of the Royal Engineers. He worked on his canvas for around two weeks, but, with German forces fast approaching, he reported that he had been 'entertained by a fair amount of enemy activity both by day and night'. Freedman was evacuated back to England in May 1940, together with the other artists, but, just as he was about to board the ship at Boulogne, he remembered that this painting was still in his hotel room, and dashed through the streets to retrieve it, under bombing and machine-gun fire.

Keith Henderson

Leaving for North Sea Patrol: Dawn

(1940)
Oil on canvas, 33 x 40.6 cm
ART LD 663

'I've caught a diluvian, oceanic cold after drawing clouds at 7,000 feet in an open Magister with ice forming on the wings,' wrote Keith Henderson to Dickey in September 1940. Henderson had been appointed official artist to the Air Ministry the previous February. The Scottish-born son of a barrister, Henderson had studied at the Slade, served in the First World War and travelled widely. His first – and as it turned out only – posting was to RAF Leuchars, near St Andrews on the Fife coast, which was initially used for aerial reconnaissance and for searching out U-boats and ships in the North Sea.

Henderson was exuberant and irreverent, persistently referring to Air Commodore Peake in his letters as 'Blondie'. He felt at home in the Leuchars officers' mess, with its hunting souvenirs and ample leather chairs, where sherry was taken before lunch. He was irritated, though, to realise that another war artist – William Rothenstein – had arrived ahead of him and had made portraits not only of the senior staff, but the 'humbler fry' as well.

Keith Henderson

A North-East Coast Aerodrome

(1940)
Oil on canvas, 69.8 x 90.1 cm
ART LD 257

Based with his wife Helen at nearby St Andrews, Henderson visited
RAF Leuchars on a daily basis, producing a steady stream of paintings
recording activities at the airfield. In diary extracts he had published in
The Listener, Henderson wrote: 'Eastward is the wonderful coast-line,
red sandstone mostly, fretted away into natural arches and pinnacles.
The jade green sea is as lovely from above as I remember it in the last
war'. Clearly popular on the aerodrome, Henderson told Dickey that
'each picture contains something of interest to each rank. Even the
mechanics in charge of the accumulators want prints!'

Henderson caught the spirit of RAF Leuchars but something –
probably his irreverent approach – caused the Air Ministry to end
his contract.

Eric Ravilious

HMS Glorious in the Arctic

(1940)

Watercolour, 46.4 x 58.5 cm
ART LD 283

By the time the war broke out, Eric Ravilious had established a strong reputation as a designer and commercial artist. He was keen to contribute as a war artist but admitted to a friend: 'they have a fair-sized list to choose from and I feel no certainty of being in the first batch'. The Committee, though, liked his work, and, in May 1940, having been commissioned as a war artist to the Admiralty, Ravilious embarked on the destroyer HMS *Highlander* for Norwegian waters. Germany had invaded Norway the previous month and British forces were attempting to recapture the strategic port of Narvik. During this time Ravilious witnessed these precarious landings by Gloster Gladiator bi-planes and Hawker Hurricane fighters on the aircraft carrier HMS *Glorious*.

When *HMS Glorious in the Arctic* went on display in July 1940, the critic Eric Newton wrote of Ravilious's work in the *Sunday Times*: 'There is something apocalyptic in his water-colours of ink-black seas, their surfaces furrowed by the grey-green wake of hurrying destroyers, their horizons broken by the ungainly silhouette of giant aircraft-carriers, while across the threatening sky and the midnight sun aeroplanes wheel madly like flocks of scattered birds.'

By July 1940, the sinking of HMS *Glorious* was made public, and the figure of 1,204 lives lost was released the following month. It is now known that intelligence failed to act on information that revealed the aircraft carrier was in danger – something that was covered up for decades.

Edwin La Dell

The Camouflage Workshop, Leamington Spa, 1940

(1940)

Oil on panel, 43 x 55.6 cm

ART LD 322

Camouflage was undertaken on an enormous scale to try to protect RAF airfields from attack. Luftwaffe pilots were equipped with folders indicating precisely where airfields in the UK were located. When enemy aircraft were brought down, these captured documents, which drew on pre-war reconnaissance missions, revealed chilling detail, including the exact locations of hangars, barracks, radio stations and air traffic control.

Leamington Spa became the centre for camouflage. Dozens of artists were sent there to devise elaborate schemes to conceal what was on the ground from enemy planes. They had the exhilarating job of flying over the sites to be camouflaged, photographing or sketching them, and then using the images to work out how best they could be concealed.

Edwin La Dell had studied at the Royal College of Art under John Nash. He explained to the Committee: 'The painting represents the interior of the workshop showing designers working on models and paper, with the maps for plotting sites in the background. Captain Glasson has seen the painting and is sure that it does not give away any military secrets.'

Dorothy Coke

ATS Air Raid Practice

(1940)

Watercolour, 26 x 40.5 cm
ART LD 377

The south coast of England saw intense activity in the summer of 1940, as the Luftwaffe and RAF fought what soon became known as the Battle of Britain. Dorothy Coke lived in Rottingdean, near Brighton, where the air war had a direct impact on everyday life. Her painting shows women in the Auxiliary Territorial Service (ATS) completing a gas drill on the beach, with aircraft activity taking place overhead.

Coke had trained at the Slade and exhibited widely in the 1920s and 1930s. Dickey contacted her in spring 1940, asking her to contribute to the war artists scheme. Within a few weeks Coke was sending her paintings up to London. 'I'm glad to get them off,' she wrote to Dickey in August 1940, 'my house doesn't feel too safe this week!'

One can feel the strong breeze off the sea in this painting, and sense the camaraderie of the women, but, when shown to the Committee, Coke's works did not go down well with Air Commodore Peake. There was possibly too much wry humour in them, but Peake found it easiest to focus on Coke's renditions of the service women. He rang Dickey after the meeting to complain that Coke had got the uniforms all wrong.

Eric Kennington
Sergeant J Hannah, VC

(1940)

Pastel, 68.2 x 47.6 cm
ART LD 638

Eric Kennington was well known for his paintings and drawings from the First World War and for some notable public sculptures. He was closely associated with the renowned adventurer T E Lawrence, and had contributed several portraits to Lawrence's account of the Arab Revolt, *Seven Pillars of Wisdom* (1926). Contracted by the WAAC in August 1940, he embarked on an intense period of portrait drawing in pastels, producing a huge body of work, much of it focusing on the RAF.

Sergeant John Hannah was a radio operator who was awarded the Victoria Cross. He had been on a raid over Antwerp, Belgium, in September 1940 when his aircraft was hit by anti-aircraft fire and set alight. Such was the severity of the fire that two of the airmen bailed out. Hannah stayed on board and managed to extinguish the flames. His quick thinking and selflessness allowed the pilot to fly the almost wrecked aircraft back to its base at RAF Scampton in Lincolnshire.

The folded arms may be a quiet indication of the injuries the teenage Hannah had endured in the burning aircraft – which contributed to his premature death from tuberculosis in 1947. He left behind a widow and three young daughters.

Eric Kennington

Air Vice-Marshal A Coningham DSO MC DFC AFC

(1940)

Pastel, 75 x 52 cm
ART LD 700

Air Vice Marshal Coningham commanded No. 4 Bomber Group which had its headquarters in a requisitioned country house, Heslington Hall, near York, where the drawing room was now crammed with telephones, maps and blackboards. Coningham, his biographer recorded, 'had one unnerving quality in that he never blinked his eyes'.

Kennington's portrait drawing made for a punishing schedule as he travelled from station to station, usually with the names of recently decorated airmen as his first priority, but frequently finding other subjects pressed upon him – which he gladly drew. By January 1941, Kennington had made 34 portraits at different RAF stations.

Charles Cundall

RAF Morse School at Olympia, Blackpool

(1940)
Oil on wood, 82.5 x 125 cm
RAF Museum FA03057

Charles Cundall was well known as a painter of panoramas and was given a number of assignments in the early months of the war. He had been keen to paint scenes of shipping activity on the River Thames, but the havoc wrought by the Blitz that September of 1940 made it impossible. He wrote to Dickey: 'My memory of what I have seen on the river will serve me one day for a really desolate picture. The most depressing sight (they do not speak of it) from London Bridge to Woolwich – no craft of any kind about apart from empty barges and two Dutch vessels. I hope Churchill felt better than I did about it when he paid a visit there on Friday.'

At some point in 1940 Cundall went to Blackpool, where a huge RAF training centre was processing thousands of new recruits. The seaside town's famous Olympic Hall was requisitioned and can be seen here hosting a Morse Code training session.

Blackboards have been set up, and coats slung over the balconies. The incongruity of flamboyant pleasure domes serving as the training hubs for the nation's airmen was not lost on the artists who visited Blackpool. Alan Sorrell considered the town 'disgustingly prosperous with a perpetual summer holiday quality about it,' while Mervyn Peake, sent there in October 1940, wrote to Clark of 'the fantastic vulgarity of Blackpool – its tawdry fustian and vast gilded beastliness'.

Charles Cundall 1940

Frances Macdonald

Graveyard: No. 1 Metal and Produce Recovery Depot, Morris Works, Cowley, Oxford

(1940)

Oil on canvas, 43.1 x 121.9 cm
ART LD 717

Frances Macdonald had studied at the Royal College of Art and was 26 when she was introduced to Clark by Oliver Simon of the Curwen Press. The Committee arranged for her to have access to the Morris Works at Cowley, near Oxford, where the wreckage of crashed aircraft – RAF and Luftwaffe – was being recycled. 'It is a curious contrast this massive dump of twisted distorted aircraft against the peaceful English landscape,' she wrote to Dickey. Her painting captures the desolation of the site, with its rutted tracks and distant pylons.

Macdonald painted a number of other scenes for the WAAC, including several of the impact of the Blitz on London.

Paul Nash

Target Area: Whitley Bombers over Berlin

(1940)
Watercolour and chalk, 58.5 x 80.1 cm
ART LD 827

It was Nash's tragedy to be dogged by ill-health for much of the Second World War. Unable to reach the studio on the upper floor of his Hampstead home, he and his wife moved to Oxford, where they rented a ground-floor flat in Banbury Road, where a room giving onto a garden became Nash's studio – his 'ivory basement'. There were new acquaintances to be made, but it was frustrating to be far from the RAF stations in the south and east of England, where so much was happening. The Air Ministry initially tried to help Nash, assigning him a room in one of its buildings in Woburn Place for him to use on his visits to London. There Nash installed a 15 x 10-foot canvas – much larger than the one he had used for *The Menin Road* (1919), his celebrated First World War painting, and an indication of the ambitious vision he had for the air war.

Charles Gibbs-Smith, Assistant Director of the Ministry of Information's Photographic Section, was now an important source of visual references for Nash. 'Can you send me a good selection of pictures of our bombing and night bombing especially of Germany and the Channel Ports,' Nash wrote to Gibbs-Smith. 'Particularly strange off effects of light, search lights, tracers, shells – all that. Anything to help me reconstruct the scenes of such operations.' To Dickey, Nash wrote: 'What I really need is whole sheaves of cast-off newspapers and weekly periodicals. Should I knock the Air Ministry or you?' Dickey duly fixed for him to have regular subscriptions to *Aeronautics* and *Flight*, and the Banbury Road studio was soon lined with photographic prints and cuttings.

From the outset Nash was expected to give an imaginative interpretation of the air war, but his works had a surrealist quality and some attributed animalistic characteristics to RAF planes. Nash invited some of the RAF officers he met back to his studio to see work in progress and was pleased to find that they liked his approach. His work did not though go down well with Air Commodore Peake, and in December 1940 Nash was devastated to find his contract with the Air Ministry terminated.

The situation was embarrassing for Clark who wrote feebly to Nash: 'We have told them how foolish they are, but a certain number yearn for the Royal Academic style'. In the end the Committee came up with a compromise: Nash would continue to paint for the WAAC, with the understanding that his paintings would be purchased on a piecemeal basis. It was a tactful solution. There was no stopping Nash and he would punctuate the war with four major oils that would speak for the air war for decades to come.

John Nash

Sunderland Flying Boat in Hangar

(1940)

Oil on canvas, 62.9 x 75.6 cm
RAF Museum FA03035

'My "honorary, unattached" commission is more or less confirmed & I am told I can get the togs' wrote John Nash to Dickey in February 1940. 'If you are a good boy I will come one day & show you my uniform.'

With no formal art school training, John Nash had nonetheless established a reputation for his meticulous draughtsmanship and had contributed works to the official war art scheme in the First World War, including *Over the Top* (1918) which depicts an event he had witnessed. The 1920s and 1930s had brought teaching posts at The Ruskin School of Art, Oxford, and the Royal College of Art.

Matters now moved swiftly for this established artist, whose reputation meant that, like his brother Paul, he was an obvious candidate for Clark's scheme. In his new fleece-lined trench coat, John Nash set off for Devonport, the centuries-old naval base near Plymouth from which Sunderland flying boats now patrolled the coast for U-boats. By May he had an established routine in Plymouth and the company of Eric Kennington, but as he commented to Dickey: 'The military discipline, as implying a constant raising of the eyebrow, is really most oppressive.' By June, Nash was back home in the Buckinghamshire village of Meadle, where he worked on this painting and reported to Dickey: 'Yes, dear boy, I feel a bit more useful now. I paint for the Admiralty, dig for Victory and Observe for the Air Ministry and tonight I am going to do a little Rifle Practice to assist in keeping the horrid Hun at bay.'

Dame Laura Knight
Corporal J D M Pearson, GC, WAAF

(1940)

Oil on canvas, 91.44 cm x 60.96 cm
ART LD 626

Daphne Pearson scans the sky for signs of activity overhead. The public would have been familiar with the story of this young woman, who earned the George Cross for her bravery in rescuing a pilot who had crashed at Detling, Kent, at the end of May 1940. As the WAAF had helped the airman to get clear of the wreckage, one of the aircraft's bombs had exploded, and she had thrown herself across the wounded man to protect him from the blast and shrapnel.

Pearson confided to her mother in August 1940 that she was worried about Dame Laura Knight's insistence that she pose with a rifle as it 'made a good line'. 'Air Min will be furious,' wrote Pearson, aware that there was a controversy raging over whether WAAFs should bear arms. Pearson's letter shows that she did not disagree with Dame Laura's wish to depict an armed servicewoman: 'if Germans kill women and children deliberately in their homes and in the streets, machine gunning, then the women must be prepared to kill to protect their children.' In the event, however, caution prevailed and the rifle was swapped for a gas respirator.

Richard Eurich
Air Fight over Portland, 1940

(1940)

Oil on canvas, 94.6 x 119.8 cm
ART LD 769

Richard Eurich had trained at Bradford School of Arts and Crafts and the Slade, and by the mid-1930s was well known for his paintings of landscapes, coastal and harbour scenes. In November 1940, he was commissioned by the WAAC to record an action that had taken place just a few weeks earlier, when, on 15 September, the naval base at Portland in Dorset had come under attack. Eurich lived in the Hampshire village of Dibden Purlieu and cycled to Portland — a six-hour journey. Along the way, Eurich would have seen many buildings destroyed or damaged.

Eurich spent five days sketching the centuries-old naval base. He learned from his Admiralty hosts about the German attack and how a force of Heinkels and Messerschmitts had been seen off by RAF fighters from six different squadrons. Back in his garden-shed studio, Eurich worked up his painting in oils, delivering the finished canvas to Senate House in mid-January 1941. In his accompanying letter, Eurich pointed out several landmarks that he had been able to include: Chesil Beach, the Whitehead torpedo works, the white cliffs of Lulworth Cove stretching out to St Alban's Head and Henry VIII's fort, Portland Castle.

Eurich was a pacifist, and the landscape is noticeably more prominent than the fighter action taking place overhead. Newton commented in the *Sunday Times* that 'it might just as well have been painted during a happy summer holiday in 1932'. The WAAC, however, were pleased with the result and saw that Eurich could bring a distinctive approach to military actions.

1941

Alan Sorrell

The 8 o'clock Parade, January 1941

(1941)

Chalk and ink wash, 32.7 x 41 cm
ART LD 1286

Alan Sorrell had studied at the Royal College of Art in the 1920s and had been awarded the much-coveted Rome Scholarship in Decorative Painting, which allowed British students to immerse themselves in Renaissance paintings and murals. Enlisting in the RAF in 1940, he trained at RAF Bridgnorth and was then sent to the Royal Aircraft Establishment, Farnborough, where, in great secrecy, aerial photography and terrain modelling were being combined to bring greater accuracy to commando and bombing missions.

Sorrell's application to be an official war artist was turned down, but he was given sketching facilities, and flights over airfields and visits to RAF stations soon gave him rich material. The Committee responded positively to his work and, from 1941 to 1946, acquired 26 artworks in a variety of media: ink, chalk, pastel, watercolour and oil. Sorrell was diligent in not revealing his whereabouts in his correspondence, which can make identifying the locations of his drawings difficult. We know, however, that he spent the winter of 1940–1941 at the training camp pictured here at RAF Bridgnorth, informing E M O'R Dickey that 'it was a bit too cold' but that he was 'memorising a good deal & getting it on paper in a quite precise way'.

On a freezing morning dozens of airmen leave their warm barracks and march to the parade ground. Leafless trees, smoking chimneys and a light dusting of snow add to the sense of extreme cold and silence, broken only by the yelling of the drill sergeant.

Charles Cundall

Physical Training at a Royal Air Force Centre

(1941)

Oil on canvas, 77.2 x 122.9 cm
ART LD 904

While in Blackpool, Charles Cundall found material for this second oil, showing scores of RAF recruits doing synchronised physical exercises, this time in the Winter Gardens' Empress Ballroom. An invited audience, perhaps grandees from the town, look on. RAF marches are very likely being played on the famous giant Wurlitzer organ – out of sight in this painting but known to be at the back of the stage. The Empress Ballroom dated back to 1896 and had recently had a new sprung floor installed, ideal for this kind of display.

Eric Kennington

In the Flare-Path

(1941)

Pastel, 53.3 x 36.8 cm
ART LD 1087

Eric Kennington preferred portraits to other forms of painting, but this work captures the atmosphere of an airfield at night. A bomber taxis onto the runway at RAF Wittering in Cambridgeshire, the red and green wing-tip navigation lights glinting in the pitch-black sky. A signal lamp illuminates the solitary aircraftman's greatcoat, reminding us that, for safe take-offs and landings, much depended on the skill and readiness of those on the ground.

The biographer Lord David Cecil, who contributed an account of visiting RAF stations to William Rothenstein's 1942 book *Men of the RAF*, described an aircraft coming into land: 'One by one the lights on the flare-path winked faintly into being. Then came a pause. All the time the stillness had been broken by the distant hum of planes; now the sound grew suddenly louder and louder till, with a roar a great black form rushed down out of the darkness.'

Paul Nash

Totes Meer ('Dead Sea')

(1941)
Oil on canvas, 102 x 152.4 cm
Tate N05717, presented by the War Artists Advisory Committee 1946 © Tate

Paul Nash had been taken aback when the Air Ministry terminated his contract, and the correspondence from this point suggests his confidence had been severely dented. He wrote to Kenneth Clark to check on the new arrangement, wanting 'to do some paintings of a fair size if this meets with your encouragement and will be what you are likely to buy'. He had an idea for a painting provisionally called 'Iron Sea', showing the wreckage of German planes at the Morris Works dump, and wrote to Dickey: 'I have already made a set of photographs and some sketches. Next week I go to Cowley to get the details for colour'.

The painting's eventual title, translated as *Dead Sea*, may have been opaque, and one wonders how many visitors to the National Gallery fully grasped what Nash had painted. It was the same scene as that recorded by Frances Macdonald (see pages 44–45), but Nash's interpretation is dreamlike and meditative. Wings, a wheel and the carcase of a fuselage can be made out among the mass of destroyed metal. The moon casts a blueish light on the scene and a dove wafts mysteriously on the horizon. 'A few weeks back, a day or two ago,' Nash later mused about this painting, 'a few hours even some of these traversed the skies, one by one they had been hurled to earth and gathered up and scattered here.' He also recalled 'a ghostly presence.... I do not mean the wraiths of lost pilots or perished crews were hovering near, it was nothing so decidedly human, but a pervasive force baffled yet malign hung in the heavy air'.

The painting was received with acclaim by the War Artists Advisory Committee (WAAC) and was shown at the National Gallery's latest display of war artists' work in May 1941. John Piper wrote a favourable review in *The Spectator*, as did Eric Newton in *The Times*, praising the 'moon-haunted, grey-green sea of twisted metal that once was German bombers'.

Eric Kennington

Sergeant R G Arding

(1941)

Pastel, 74.4 x 54 cm
ART LD 1243

This portrait – together with two others of sergeant pilots – appeared in Eric Kennington's privately published booklet *Pilots, Workers, Machines* (1941), which featured seventeen of his portraits of soldiers, sailors and airmen. Kennington explained to readers how he met the three airmen on return from a 'ship-sinking trip off the Dutch coast'. He recalled, 'I insisted on having them sit as they came in, with their tight equipment carelessly loosened.' The airmen had just lost a fellow crew member and told Kennington about the dangerous nature of their work: 'it is no secret that they are putting all these ships down from mast level, and mast and plane wing sometimes collide.'

J B Priestley, the novelist and writer of the popular BBC series of Sunday evening *Postscripts*, wrote the introduction to Kennington's booklet, and observed of the airmen he met at this time: 'They do not go swaggering round the place, but have rather better manners than the average young man or girl...They love flying itself but are as well aware of the fundamental idiocy of this huge aerial warfare, with its vast cost and often indiscriminate destruction, as any thoughtful civilian is.'

Richard Arding was killed, together with the rest of his Wellington bomber crew, on an anti-submarine patrol in January 1944.

Leslie Cole

Manufacturing 250lb Bombs, GWR Yard, Swindon

(1941)

Watercolour, 35.5 x 52 cm
ART LD 1349

Leslie Cole had grown up in Swindon, and studied at Swindon School of Art, followed by the Royal College of Art. By the time the war broke out, he was teaching lithography at Hull College of Art. He wrote to Clark in July 1940, sending him examples of his lithographs. The works clearly impressed the Committee and Cole was given access to paint trawlers and a destroyer which was being refitted in Hull's dry dock.

As a student in Swindon, Cole had sketched the furnace workers in the Great Western Railway's immense railway repair works, one of the largest covered areas in the world, where locomotives had been manufactured and repaired for over a century. The premises were now turned over to war work, the furnaces which earlier had produced parts for trains now turning out thousands of bombs. Cole visited Swindon regularly as his father still lived there, and it is possible that he was given informal access to industrial sites through the foremen he knew.

W.A.A.F. 1 Instrument mechanics at work.

Dorothy Coke 1941

Dorothy Coke

WAAF Instrument Mechanics at Work

(1941)

Watercolour, 28.8 x 43.1 cm
ART LD 1298

Intense concentration is required by these WAAFs (Women's Auxiliary Air Force), their workbenches lit by Anglepoise lamps as they assemble the components of aero-engines. In the centre a mechanic works her lathe, while on the right another is using an awl for some delicate operation. Dorothy Coke's watercolour is stiffer and more punctilious than her earlier works for the WAAC, which had earned such disapproval from Air Commodore Peake. It is possible that Dickey – who was on good terms with Coke – had steered her away from anything remotely frivolous. Coke clearly enjoyed the commission, sending Dickey an extra drawing 'for sheer love because I saw these girls working with a sort of ferocious intensity'.

Anglepoise lamps – invented in 1932 by the car designer George Carwardine, and manufactured by the Midlands company Herbert Terry – were supplied in large numbers to Bomber Command to enable navigators to read their maps with maximum clarity at night.

Paul Nash

Battle of Britain

(1941)

Oil on canvas, 122.6 x 183.5 cm
ART LD 1550

1941 was a difficult year for Paul Nash. A love affair with the painter Eileen Agar had ended, his health had deteriorated and the earlier rejection by the Air Ministry hung over him. He had been writing his autobiography, conscious that his time could be running out.

The Ministry of Information's photographers continued to supply fresh and dynamic imagery. With the help of his assistant, Barbara Fell, Charles Gibbs-Smith sent Nash more photographs, including one showing the aerial spectacle produced by searchlights, tracer bullets and shell bursts. 'Herewith yet another which Miss Fell has discovered. This, I think, is even better and looks more like Paul Klee than ever.' The image described may have been the photograph taken by Sergeant Len Puttnam (see page 16), which has a strong resemblance to this painting.

Drawing on his cache of photographs, Nash worked through the summer on his painting, delivering it in the autumn. Aware that it might raise eyebrows, he gave Clark a detailed explanation of what it depicted: 'The painting is an attempt to give the sense of an aerial battle in operation over a wide area and thus summarises England's great aerial victory over Germany. The scene includes certain elements constant during the Battle of Britain – the river winding from the town and across parched country, down to the sea; beyond, the shores of the Continent, above, the mounting cumulus concentrating at sunset after a hot brilliant day; across the spaces of sky, trails of airplanes, smoke tracks of dead or damaged machines falling, floating clouds, parachutes, balloons. Against the approaching twilight new formations of Luftwaffe, threatening...'.

Clark's reply was hardly reassuring. 'I must write at once to say that I think it one of the most thrilling works of art yet produced by the war,' he began, and felt that Nash had 'discovered a new form of allegorical painting,' but went on to say: 'it is possible some people may not tumble to the idea immediately, and so I do not think I will show it to my Committee until it is framed and glazed. But I am getting Stiles round to-morrow and we shall do the best we can with it.'

Clark had, however, seen that a series was emerging and 'encouraged the plan of another and then another large oil to make it a set of battles': the Battle of Britain, the Battle of the Atlantic and the Invasion of Germany. For all the carping and discouragement, there was now a plan to be followed.

Leslie Cole

Two WAAF Balloon Workers

(1941)

Watercolour, 40 x 57.5 cm
ART LD 1564

Filled with hydrogen and tethered to the ground, barrage balloons were used to deter attacks by enemy dive bombers by forcing them to fly higher. By the start of 1943, roughly 18,000 women were working on over a thousand barrage balloon sites across the UK.

As a resident of Hull, Leslie Cole got to know about '17 Balloon Centre' where barrage balloons were being repaired by teams of WAAFs. 'The girls say they enjoy working in the balloons,' wrote Cole to Dickey, describing how he had wriggled through a small valve into 'a calm green twilight' where the girls, wearing rubber-soled shoes, 'move silently and are accompanied by weird shadows'.

Leslie Cole

Making Moulds from Bomb Patterns

(1941)

Watercolour, 52.7 x 36.1 cm
ART LD 1689

Also in Hull was the sprawling Edwardian-era 'Ideal Boiler and Radiator Works' factory, now turned over to weapons manufacture. There Cole met yet more bomb makers who spent their days pouring molten metal into 12-unit moulds. He wrote to Dickey: 'The bombs are on a continuous moving belt and the rate of work is terrific'.

Frank Graves

An Afternoon Show by an ENSA company in a NAAFI Canteen Hut

(1941)

Oil on panel, 40.7 x 73.6 cm
ART LD 1690

Dublin-born Frank Graves had trained at Belfast Art School and became a scene-painter at Ealing Film Studios. During the war he worked for ENSA – the Entertainments National Service Association – which toured plays and musical performances for the forces. By 1941 Graves was managing an 18-strong company that performed at a different camp each night.

With so little free time, it took Graves six months to produce this painting. 'There were weeks when travelling and living conditions conspired against its advancement,' he told Dickey, adding that he thought ENSA should have its *own* war artist – something he would be taking up with its director, Basil Dean.

Graves employs a triptych-like approach to his subject. A portable theatre has been battened onto the canteen hut's steel joists and a cabaret is in progress. Offstage a uniformed figure cues some dancers, who are rapidly changing costumes. The RAF audience sit attentively, conscious perhaps of the presence of a glamorously dressed visitor in the front row.

Eric Ravilious

Morning on the Tarmac

(1941)

Watercolour, 48.5 x 56 cm
ART LD 1712

In early 1941 Eric Ravilious was invited to lunch by Lord Willougby de Broke, Deputy Head of Air Ministry Public Relations, who had replaced Air Commodore Peake on the WAAC.

Willoughby de Broke and Ravilious came from very different backgrounds. Lord Willoughby was the twentieth in a long line of barons going back to the fifteenth century and, a keen aviator, had in 1932 staged his own flying display on his estate at Kineton in Warwickshire. Ravilious came from a much more modest background, but the war often saw such differences dissolve, and over game pie and cake in Willoughby de Broke's Pall Mall club, Ravilious learned what topics the Air Ministry had in mind for him. 'Lysanders are the immediate prospect,' he reported to Dickey, 'with the Coastal Command Sunderlands and Catalinas to follow.'

In the autumn Ravilious travelled to Scotland, staying initially with John and Christine Nash at the cottage they had rented at Crombie Point on the Firth of Forth. From there he went to Dundee to be stationed with the Fleet Air Arm, the branch of the Royal Navy that operated aircraft from its ships.

The Walrus aircraft seen here were used for air-sea rescue work. 'I do very much enjoy these queer flying machines,' Ravilious wrote to Dickey, 'and hope to produce a set of aircraft paintings. I hope Paul N. hasn't already painted Walrus's — what I like about them is that they are comic things with a strong personality like a duck, and designed to go slow. You put your head out of the window and it is no more windy than a train.'

Eric Ravilious

RNAS Sick Bay, Dundee

(1941)

Watercolour, 48.8 x 54.4 cm
ART LD 1719

In placing an empty hospital bed at the centre of this composition, Ravilious shows his confidence that the Committee would accept a scene with a subtle relationship to the war. The Royal Naval Air Service's base at Stannergate, RNAS Dundee, dated back to the First World War and had re-opened in July 1940 for training recruits. Here though it is the craftsmanship of the carpenters who built the hut that has prominence, rather than the activities of the RNAS.

The bed, covered with a bedspread embroidered with a Royal Naval anchor, awaits its next occupant, who will have a view of the placid Tay Estuary, dotted with Walrus amphibious biplanes. Ravilious's paintings rarely include people, producing a disarming sense of absence or detachment.

1942

Eric Ravilious

Walrus Aircraft on the Slipway

(1942)

Watercolour, 48.2 x 54.6 cm
ART LD 1721

With a limited, pale palette, Eric Ravilious captures more Walrus planes, this time touching down from their air-sea rescue patrols. Ravilious wrote about his assignment: 'I must say it is most enjoyable... it is a joke dressing up with flying suit, parachute, Mae West and all and climbing in over the nose. Sometime this week they promise a trip in the rear gunner's cockpit which is uncomfortable but has the best view: the only drawback is that I have to do a number of simple (?) mechanical things with hatches when the sea-plane comes down on the water. How trusting they are!'

Leslie Cole

Interior of an Aircraft in Flight

(1942)

Oil on canvas, 50.8 x 40.6 cm
ART LD 1878

In early 1942, Leslie Cole was given access to RAF Speke on the outskirts of Liverpool, where he took part in the test flight of a Type 160 Bisley twin-engined bomber, developed from the Bristol Blenheim and hot off the production line.

Cole later reported to E M O'R Dickey that not only had he been allowed up in the plane, but the pilot, Squadron Leader Palmer, had afterwards agreed to sit for his portrait – allowing Cole to insert this close-up into his painting.

Charles Cundall

Servicing a Liberator

(1942)

Oil on canvas, 69.2 x 105.4 cm
ART LD 2485

In May 1942 Charles Cundall was sent to RAF Nutts Corner in County Antrim, Northern Ireland, an important transport hub for aircraft arriving from the United States. 'I was very fortunate in getting here when I did, in fact I couldn't have timed it better,' Cundall wrote to Dickey. Liberators – American heavy bombers – were arriving from San Diego, California, for use on convoy-escorting duties by the RAF – the first aircraft to routinely cross the Atlantic.

Eric Ravilious

De-icing Aircraft

(1942)

Watercolour, 46.8 x 62.8 cm
ART LD 1856

Eric Ravilious seems to have struggled with the aeroplane as a subject initially, at one point complaining: 'air pictures don't have enough horizontals and verticals; they are all clouds and patterned fields and bits and pieces of planes'.

This painting was made at RAF Clifton, near York. In the background a groundsman on a stepladder is applying de-icing liquid to the wings of a de Havilland Dragon Rapide. Another stands ready with a spade to scrape away the snow and ice. The ground is dotted with the footprints of the groundsmen, who worked long hours in freezing temperatures to ensure that the planes were safe to fly.

Ravilious wrote to his wife Tirzah Garwood of his latest posting and the thrill of a flight over the Yorkshire moors with the station's Commanding Officer: 'The people I like a lot especially the CO who flew me up and down Yorkshire this afternoon and kept pointing out abbeys and ruins. He promises to take me over Greta Bridge and with Richmond next time. But it was jolly cold, even with two jumpers and a great coat, and a warming parachute.'

Paul Nash

Defence of Albion

(1942)

Oil on canvas, 121.9 x 182.8 cm
ART LD 1933

In this, the second of Paul Nash's series of oils to illustrate three facets of the air war, a Short Sunderland flying boat swoops over the Isle of Portland in Dorset, engaging with a German submarine which has surfaced from the squally sea. In the distance slabs of Portland stone sit abandoned on the shore.

Nash knew the Portland peninsula well from compiling the 1935 Shell Guide to Dorset. It was 'a place apart, independent in character', Nash had written then, and he had included in the booklet his own photograph of the giant blocks of Portland stone – quarried there since Roman times.

Nash suffered a severe bout of bronchitis at the start of 1942 and was too weak to make the journey to the south coast. He had asked Eric Ravilious to record certain details for him, but Ravilious had been unable to help. His morale now at a low ebb, and beset by money worries, Nash despatched the painting to London, writing to Dickey: 'It's the Boys Own Paper all right!' adding that he hoped Kenneth Clark and the others 'fall for my blonde beast'.

In a separate letter to Clark he explained: 'Albion is not necessarily conveyed only by a heart-breaking close-up of the Cliffs of Dover but perhaps by a glimpse of those quarries in Portland'. It was from Portland stone that so many of London's historic buildings had been constructed: the Palace of Westminster, the Tower of London, St Paul's Cathedral, the city churches – all now damaged, some destroyed, in the Blitz. In choosing the term 'Albion' – first used by ancient Greek geographers to describe the island of Britain – Nash gave the painting a deliberately archaic title, underlining the nation's long history.

The Committee were generally enthusiastic about Nash's latest work, but there was one dissenting voice: the Air Ministry representative complained that the Sunderland's wings were patently too small to get the plane airborne. Word reached Nash whose response to Clark was that the Air Ministry types had 'less imagination than a Jerusalem artichoke'.

Sir William Rothenstein
First Officer Lois Butler: Air Transport Auxiliary

(1942)

Sanguine crayon, 52.7 x 38.2 cm
ART LD 1982

Here William Rothenstein depicts the gimlet-eyed Lois Butler, a pilot in the Air Transport Auxiliary (ATA), whom he has drawn in 'society portrait' mode. Married to the Chairman of the de Havilland Aircraft Company, Canadian-born Butler had competed in the controversial 1936 Olympics as an alpine skier and had taken part in international aviation events. The ATA was a civilian organisation responsible for flying aircraft from their place of manufacture to the airfields where they were deployed. Around ten per cent of its pilots were women.

A noted artist, former Principal of the Royal College of Art and author of a three-volume memoir, Rothenstein was well known not just in the art world, but in the upper echelons of the services as well. He mobilised his contacts and visited numerous airfields and headquarters in order to capture the essence of the RAF at war. By the end of March 1940, when the War Artists Advisory Committee (WAAC) was only just starting to commission its artists, Rothenstein had chalked up an impressive number of portraits of senior air officials. The WAAC correspondence reveals a strained relationship between Rothenstein and the Committee, who seems to have been united in exasperation at his behaviour. Dickey took a more resigned approach, writing to Clark: 'If he hangs about aerodromes and induces the rank and file to sit for him, what right have we to interfere?'

The Committee's irritation with Rothenstein must have increased further when, in 1942, his book *Men of the RAF* was published, featuring 40 of his portraits. Rothenstein had a gift for writing as well as for art, and his book, with its account of staying with 'Bomber' Harris and his wife in Yorkshire, taking flights in a Sunderland at Pembroke Dock, and being given the freedom of various Ops Rooms, made for a compelling read.

1st Off Lois Butler A.T.A. /3

David Bomberg

An Underground Bomb Store

(1942)

Charcoal on paper, 53.3 x 66 cm
ART LD 2119

'You will be glad to hear,' wrote Dickey to Willoughby de Broke in March 1942, 'that I find I was right in saying that Bomberg has been approved by M.I.5, in spite of his menacing appearance.' The British security service monitored Communist sympathisers, and Bomberg had been a party member. When supplying his biography to the WAAC, moreover, he disclosed that he had spent six months visiting Moscow and Leningrad in 1933. His origins in London's Jewish East End made him different in the Committee's eyes from most of the other artists, and, whether from mild suspicion or outright antisemitism, they seem to have been determined not to commission him. This despite the fact that Bomberg had produced an important work for the Canadian War Memorials Fund during the First World War.

Bomberg wrote to the Committee repeatedly, wanting to know why he was being overlooked. In desperation he sought the support of his old patron Sir Ronald Storrs. Bomberg had worked on commissions for Storrs in Jerusalem in the 1920s, when the latter was Military Governor there under the British Mandate for Palestine. Storrs duly raised the matter with Clark who wrote back with some revealing views: '...the trouble about Bomberg is that my Committee do not really like his work. He is quite as skilful as many of the artists we employ and there is no academic prejudice against him, but like so many of his race his work looks artificial and done for effect, which is the last thing that we want our war records to be. I would rather they were a little dull and naive. I have often tried to help Bomberg in the past, and have bought his work but never hung it up, and there are several English painters whom I really do admire and who are equally hard up. If only it were possible to discourage the Jews from painting.'

David Bomberg was eventually given a commission — one so literally obscure it could have been regarded as an insult. He was sent in April 1942 to Burton upon Trent, where a disused gypsum mine was being used to store thousands of tons of high explosive bombs pending their transportation to airfields.

David Bomberg

Bomb Store

(1942)

Oil on canvas, 59.6 x 75 cm
ART 16293 © The Estate of David Bomberg. All Rights Reserved, DACS 2024

Although the site was dark and 90 feet underground, this did not deter Bomberg, who was so absorbed by his surroundings that he soon ran out of canvas and had to draw and paint on greaseproof paper. The visit had been 'a thrilling one,' he wrote to Dickey, the subject 'rich with possibilities'. More than that, the bomb store was surely 'worthy of a great memorial panel – a memorial to the heroism of that kind of labour'. The Committee did not share Bomberg's vision, however, and worse, the artist was dismayed to realise that his drawings had not gone on display alongside other recently acquired works at the National Gallery. He asked the Committee outright whether he was 'out of favour' and received a non-committal reply.

After his death though, David Bomberg's genius began to be appreciated, and by the time the Imperial War Museum purchased this painting in 1989, the prices of his works had soared. The museum was only able to afford this piece with assistance from both the National Art Collections Fund and National Heritage Memorial Fund.

Charles Cundall

Prestwick Airport

(1942)

Oil on canvas, 99 x 189.2 cm
ART LD 4803

'I'm staying here for a time, waiting for a plane,' Charles Cundall wrote to Dickey on 28 June 1942. 'It is most thrilling and interesting here and I hope to get a good picture out of it.'

On the Ayrshire coast, 30 miles south-west of Glasgow, Prestwick Airport served as the reception centre for thousands of aircraft from the United States and Canada, many on their way to Europe, North Africa and the Middle East. Aldergrove in Northern Ireland had been the initial choice for this vital strategic base, but the Ayrshire coast offered better weather. As well as heavy bombers, fighter aircraft and planes carrying VIPs arrived at Prestwick, so that it became a 'historic spot in the geography of the air,' according to the 1945 Ministry of Information booklet *Atlantic Bridge*. 'Throughout every 24 hours, aircraft taxi up to the concrete table in front of the mansion and disgorge passengers and crews.'

Eric Ravilious

Runway Perspective

(1942)

Watercolour, 46.8 x 55.1 cm
ART LD 2123

In the summer of 1942, Eric Ravilious travelled south to be with his wife, who was seriously ill. While staying at their rented home at Ironbridge Farm, Shalford, Essex, he made a series of watercolours at nearby RAF Sawbridgeworth. They would be his last contribution to the war artists scheme.

The chalklands of Hertfordshire did not have the rugged drama of Scotland and Yorkshire, but here Ravilious captures the huge skies remembered by so many airmen who flew in this region of England. The Spitfires which soar over the runway are drawn with Ravilious's familiar delicacy of touch – the propellers whirring against the cloud-studded sky. Next to the runway a groundsman holds a red windsock to show the pilots the direction of the wind.

Eric Ravilious
Spitfires at Sawbridgeworth, Herts

(1942)

Watercolour, 46 x 62.2 cm
ART LD 2125

Spitfires get ready for take-off into a cloud-studded sky. Ravilious's almost translucent work conveys the lightness and agility of these planes, their upturned noses and raised wings suggesting an eagerness to be airborne. The sun casts shadows on the 'hard stands' – the curved concrete areas deliberately sited some distance from the runway, so that, in the event of a raid, damage would be minimised.

Eric Ravilious

Elementary Flying School, Sawbridgeworth, Herts

(1942)

Watercolour, 45.7 x 54.6 cm
ART LD 2129

Corn-stalks rustle below the gusts from a Tiger Moth's propeller. Beyond can be seen the airfield from which this training plane took off, with its camouflaged huts, stationary aircraft and weathervane.

In early July 1942, Ravilious travelled to London for a dinner organised by Clark to mark the departure of Dickey as Secretary to the WAAC. The gathering took place at the Eiffel Tower – a restaurant with a Bohemian aura in Percy Street, Fitzrovia, known to have been favoured by the war artists of the First World War. Richard Eurich wrote afterwards of conversing with several noted artists: Henry Moore had been drawing in coal mines; John Piper painting watercolours at Windsor Castle and Graham Sutherland recording blast furnaces. Barnett Freedman had made a 'rambling speech' praising Dickey, with some humorous asides. At the end of the meal Ravilious led the party up to the Holly Bush pub in Hampstead (another artists' haunt – we can imagine heads turning as this illustrious party arrived), after which Clark invited everyone back to his newly-purchased Hampstead house, Capo di Monte. Ravilious described to Dickey how the evening had ended 'at a late hour with Barnet, Harry Moore and Sutherland in high spirits'.

The following month Ravilious travelled to Iceland. On 1 September, while at RAF Kaldadarnes, he joined the crew of one of three planes that were taking off to search for signs of life after a Lockheed Hudson had gone down in the sea. The plane Ravilious was on was reported missing, and it soon became clear that he and the crew had lost their lives.

Ravilious's death was felt keenly by his circle, the Committee and his many admirers. Tirzah Garwood was left with three children to look after, and, on account of there being no proof of death, faced a long struggle with the authorities to obtain a widow's pension.

Leslie Cole

Stirlings in Production

(1942)

Oil on canvas, 59.5 x 89.5 cm
The Cheltenham Trust and Cheltenham Borough Council, 1947.124,
© The Wilson /Bridgeman Images

Twelve workers in overalls crouch, stretch and crawl as they assemble the various components of a Short Stirling bomber's fuselage.

Leslie Cole's painting shows an activity which had grown exponentially. Lord Beaverbrook, the Canadian owner of the *Daily Express*, had been appointed Minister of Aircraft Production by Churchill in May 1940 and oversaw a legendary output. Nothing was to stand in the way of the effort to expand Britain's air capacity, which aimed to produce over 2,500 aircraft a month. Hundreds of extra factories were established, and the Ministry was agile in moving production around the country according to need, setting up what were known as 'shadow factories' – subsidiaries of some of the major establishments, in more rural and therefore safer locations.

Cole had read press stories about the new four-engined bomber, and in the summer of 1942 managed to secure access to the South Marston shadow factory near Swindon. His handling of the subject – in particular his ability to show the simultaneous activities of several people within the composition – impressed the WAAC, who eventually gave Cole a salaried position.

Eric Kennington

Captain W Mohr: A Squadron Commander of the Royal Norwegian Air Force Serving with the RAF

(1942)

Pastel, 61.5 cm x 53.8 cm
ART LD 2322

Captain Wilhelm Mohr had arrived in the Shetlands in the spring of 1940 on the *Sjøgutten* – the first of many fishing boats which would bring Norwegians out of their Nazi-occupied country.

Mohr went onto play a notable role in the war. He travelled to Canada and trained Norwegian pilots near Toronto; returned to Britain and led a Norwegian fighter squadron in attacks over France; was awarded the Distinguished Flying Cross (DFC) for his actions during the Dieppe Raid of August 1942; and later supported ground forces during D-Day and the advance through Belgium and the Netherlands.

Mohr was one of hundreds of young men who managed to escape occupied Europe and join the RAF, with Polish and Czech pilots prominent among them.

Leslie Cole
Night Scene in a Watch Office

(1942)

Oil on canvas, 49.5 x 66.6 cm
ART LD 2503

In July 1942 Leslie Cole asked the WAAC for a 'short roving assignment' and 'also to do some work (especially night flying)'. He had in mind RAF Leconfield, where he had recently been teaching, and also RAF Driffield, north of Hull, which was 'operational' and the likely subject of this painting.

Cole depicts a scene that was repeated nightly in bomber stations across Britain. From the upper floor of a standard two-storey watch office, the controllers look out onto the moonlit airfield where a bomber is coming in to land. The wireless operator in the foreground maintains contact with the wireless operator of the plane, while his colleague guides the pilot's landing.

Alexander Sonnis
Balloon Operations at Night

(1942)

Oil on canvas, 41.2 x 56.3 cm
ART LD 2113

Sonnis had been studying at the Royal College of Art, but the war found him in No. 926 Barrage Balloon Squadron in Eccles, Manchester. Confined to the fabric repair shop, his job involved painting silver 'dope' onto balloons all day and, with no access to other parts of the balloon base, he was unable to sketch. He had an ally and mentor, however, in the artist Joseph Gray, now working on camouflage at a senior level for the Ministry of Supply in London. Gray wrote to Dickey enclosing some of Sonnis's drawings: 'He is a very sensitive chap – very much out of his element now & even if one small drawing were purchased I am sure it would be a great encouragement to him.'

Sonnis was duly given permission to sketch and somehow found a space to paint. He would have known from conversations with the women balloon operators just how difficult their work could be, and his painting shows them battling the elements at night to keep their balloon under control, their fingers aching and raw from tugging at the taut cables.

'It was a ghastly job,' wrote the documentary-maker Harry Watt, who had made a film about the balloon service. 'Balloons were boring things to start with, hanging around at the end of their cables like elephants that have had bad news, liable to break away in the middle of the night and have to be chased across the countryside, and the sites themselves were often in the dreariest and most inaccessible places.'

We can sense from the exuberant colours the sudden release of creativity in Alexander Sonnis – a young man whose art training had been so abruptly cut short. By the time the painting went on display in the National Gallery in the autumn of 1942, he had been posted first to Ipswich and later to Weybridge, and was unable to attend the preview.

Leslie Cole
Ground Operational Exercise (GROPE)

(1942)

Oil on canvas, 50.8 x 70.5 cm
RAF Museum FA03010

In September 1942 Leslie Cole went to the bomber station RAF Harwell in Oxfordshire and was allowed to witness the training of aircrew in a state-of-the-art darkened space. Bomb bursts, flak, tracer shells and fires flared across the room, and powerful coloured torches gave the illusion of searchlights.

Cole seems to have positioned himself alongside the crew, from where he could get the full force of the simulated experience and see the faces of the supervising officers in the booth on the left. Their job, he reported to Dickey, was to 'think up "fast ones" to add to the fun'.

Lowes Dalbiac Luard

Pressing Repairs

(1942)

Ink and pastel, 49.4 x 47.6 cm
ART LD 4227

Mechanics in overalls examine the engine of a Vickers Wellington bomber. The Civil Repair Organisation oversaw the work of around a hundred companies which ensured that aircraft were repaired and returned to service. Lowes Luard captures the collective effort and attention to detail that these huge and complex machines demanded.

A painter and etcher, well known for his detailed studies of horses, Luard belonged to an earlier generation of artists, having trained at the Slade with Augustus John and Ambrose McEvoy.

Alfred R Thomson

Corporal Lilian Levy, WAAF

(1943)

Oil on canvas, 54.2 x 39.6 cm
ART LD 2848

With calm pride, Lilian Levy wears the two stripes which denote her corporal status – junior to a sergeant, but senior to an aircraftwoman. WAAFs (Women's Auxiliary Air Force) were recruited as young as 16, leaving their homes to become part of the huge force that supported the RAF. They learned skills they could not have predicted, including driving trucks, repairing aircraft and instruments, meteorological forecasting and working on codes and ciphers.

Alfred Thomson had been deaf since very young, but progressive specialist schools had expanded his horizons. Despite opposition from his father, he had attended the John Hassall School of Art in Kensington, and become a successful commercial artist, devising, among other things, a series of posters for the London North Eastern Railway, which contrasted the Victorian rail industry with the modern ways of the 1930s. By the time Thomson painted Levy's portrait in 1943, he had completed a number of commissions for the War Artists Advisory Committee (WAAC), including one of textile manufacturers sewing army uniforms and a portrait of the 16-year-old West Bromwich Air Raid Precautions heroine, Charity Bick.

Evan Charlton
A Parachute Factory

(1943)

Oil on panel, 51.1 x 76.2 cm
ART LD 2908

Women machinists sew white silk parachutes which will be vital to the survival of airmen on missions. To the right a parachute is being laid out for checking and folding, while in the background the machinists' output is being stacked, ready for despatch. Thousands of airmen owed their lives to parachutes. Equipped with a cloth evasion map, a water bottle, foreign currency and a compass, many were able to take refuge in farms and barns, at great risk to those who helped them.

Airmen who bailed out would often send thank-you notes to the packer of their parachute: the machinists put their names and addresses inside each package. The responsibility of accurate packing weighed heavily on this workforce. One woman remembered a bloodstained parachute that had not opened being sent back so that she could investigate what had gone wrong: 'the girls fell silent when they brought in the suit and placed it on the work bench'.

Evan Charlton was London-born and had trained at the Slade. After teaching in Bristol, he was appointed Head of Cardiff School of Art, and it is likely that he painted this scene at the British Parachute Company in Cardiff.

John Berry

A Pathfinder

(1943)

Oil on canvas, 91.4 x 71.1 cm
ART LD 2939

An airman in his leather flying jacket and cap sits in front of a map, his navigational tools spread out in front of him. The portrait speaks of Berry's respect for the aircrew who were flying nightly over Germany. It has been suggested that, rather than a portrait of one of the elite 'Pathfinder Force', the title is being used more loosely to describe a navigator.

Berry grew up in Hammersmith, the son of a London Underground foreman, who had left the family early in Berry's life, leaving Grace Berry to bring up her son and daughter on her own. She moved them into her own mother's home, where, as Berry later recalled, they lived on a pound a week. The young Berry was for a time hospitalised with tuberculosis. It was against considerable odds, therefore, that in 1934 Berry won a place at Hammersmith School of Art. There one of his tutors, Alfred Egerton Cooper, took a particular interest in his progress, inviting the young Berry to his studio in Glebe Place, Chelsea. Working an 18-hour day to support himself, Berry won a scholarship to the Royal College of Art. The year was 1939, however, and, with the outbreak of war, he felt obliged to enlist and, joining the RAF, trained as a radar operator and was posted to the Middle East.

In 1943, with Berry away on active service, it was his mother Grace who corresponded with the WAAC, describing how her son had gone to school at the age of four and 'always had a tendency for a pencil and paper from twelve-month-old'. She knew from his letters home how, having somehow acquired paints, and produced a poster design, his talent had been spotted, resulting in his transfer to Public Relations headquarters in Cairo.

After the war John Berry became a prolific illustrator of Ladybird books, the long-running series designed to help children learn to read, which included among its titles *The Airman in the Royal Air Force* (1967).

Alan Sorrell

A Hutted Encampment

(1943)

Ink wash, 42.8 x 76.2 cm
ART LD 3077

By 1943 Alan Sorrell had been working for two years on aerodrome camouflage for the Air Ministry Buildings Directorate. He redoubled his efforts to be given time off to complete more drawings and paintings. As he pointed out to the Committee in February 1943, he had a unique experience of RAF camps 'in that I have lived in them as an airman (for nine months) visited them and flown over them as an Air Ministry officer and finally (or more properly, firstly,) assisted in the siting and planning of them'. The Committee responded positively with a series of short contracts.

In this detailed aerial perspective, Sorrell records daily life at a typical airfield. Nissen huts provide sleeping quarters. The buildings belching smoke are presumably cookhouses and for refuse disposal. Bicycles are used by servicemen and women to move around the airfield. The bird's-eye view hints at the beginnings of Sorrell's post-war career as an archaeological illustrator, reconstructing aerial views of ancient settlements and towns.

Alan Sorrell
The Officers' Mess at an RAF Station

(1943)

Watercolour, 31.1 cm x 73 cm
ART LD 3135

Sorrell's watercolour depicts Bradwell Lodge, on the flatlands of Essex, where the night fighter base RAF Bradwell Bay was often the first airfield that could be reached by pilots of damaged aircraft returning across the North Sea. The neo-classical house had been bought just before the war by the well-known journalist and MP Tom Driberg. Requisitioned by the RAF, the once stately garden now features four Nissen huts. Driberg later recalled in his memoir:

'It was difficult not to wince as robust young men slid down the Adam staircase on trays or threw chamber pots full of beer from end to end of the hall. But any remonstrance would have been unthinkable: these young men were going out night after night (as they put it, with self-mocking irony) "dicing with death"; and almost every night too many of them did not come back. One, a Canadian, asked me to get him a new cigarette lighter (difficult then to find). I gave it to him. Next night he was killed.'

Mervyn Peake
The Evolution of the Cathode Ray (Radiolocation) Tube
(1943)

Oil on canvas, 85 x 110.4 cm
ART LD 3685

By 1943 Mervyn Peake, having completed his training in Blackpool, was living at a remote, tented camp near Clitheroe in Lancashire, where volunteer troops from Jamaica were building pontoon bridges. His efforts to get commissions from the WAAC had come to nothing, despite earlier intimations that he would get work. Kenneth Clark had though done Peake the great favour of writing to his commanding officer and asking that he be given time off to draw, and the army turned a blind eye to the fact that Peake was both drawing and also writing a great deal. In May 1942 Peake had what he described as 'a nervous collapse' and was sent to an asylum in Southport – 'irritable as a bereaved rattle-snake and apt to weep on breaking a bootlace,' as he described himself to a friend. That autumn he was given a contract with the Ministry of Information's (MOI)'s studios, only for it to be terminated within a few months – Peake's 'highly individual style' not being suited to the MOI.

In January 1943 the WAAC finally found him a suitable topic to paint. Peake was sent to the famous Chance Brothers factory in Smethwick, near Birmingham. There the factory's agile glass-blowers were performing a task vital to the air war – making 7,000 cathode-ray tubes a week to supply the needs of radar.

Mervyn Peake

Glass-blowers 'Gathering' from the Furnace

(1943)

Watercolour, 50.8 x 68.5 cm
ART LD 2851

The Chance Brothers factory dated back to 1824, and Peake wrote of his visit: 'I found on entering the huge, ruinous, grimy, wharf-walled buildings a world upon its own, a place of roaring fires and monstrous shadows'.

The cathode-ray tubes were made from what was known as 'Hysil' glass – a type of Pyrex. Peake was clearly taken by the ballet-like poses struck by the glass-blowers. The WAAC Secretary was now the artist George Elmslie Owen, with whom Peake was familiar as both had attended Westminster School of Art. Peake wrote to his old friend, who may well have been instrumental in getting him the commission: 'I am anxious to turn in the very best work of which I am capable and feel that in the drawings which I am now submitting the Committee will see that the Subject is a big one and from both the Documentary and aesthetic standpoints of interest.'

The experience stayed with Peake, who in 1950 gave the title *The Glass-blowers* to an anthology of his poems, describing the men he had drawn as 'jugglers in a world of grime and firelight'.

Stephen Bone

Air-sea Rescue

(1943)

Oil on canvas, 76.2 x 63.5 cm
ART LD 3213

Using high-speed launches, Air Sea Rescue squadrons helped to locate and rescue airmen who bailed out over the ocean. Aircrew who were able to inflate their dinghy might survive if discovered quickly, but thirst, cold and injuries sustained when their aircraft hit the water all combined to lessen their chances, and many airmen succumbed to hypothermia. If the wireless operator was able to send a communication giving the crew's position just before they ditched, their chances of being saved were greatly increased.

Once a dinghy had been inflated, fluorescent liquid automatically spurted out as a beacon to alert rescue crews, but it was not easy to locate 'a minute shape upon the grey wastes of the sea' as an MOI booklet explained. Standing on the deck of this launch, the crewman scans the sky for the plane which will signal to him that signs of life have been spotted. After locating the dinghy, nets were let down over the side of the launch so that the frozen airmen could climb aboard.

Stephen Bone painted this scene during a three-month commission which took him to Stornoway in northern Scotland. Public awareness of the work of this branch of the RAF grew substantially when the film *For Those in Peril* was released in 1944. A directorial debut for Charles Crichton, the film was based on a short story by the pilot and author Richard Hillary.

Alfred R Thomson

Grafting a New Eyelid

(1943)

Oil on canvas, 101.9 x 76.2 cm
ART LD 3602

Aircrew were vulnerable to burns arising from fuel igniting, and the Second World War saw advances in the treatment of these injuries. At the 60-bed plastic surgery unit at Princess Mary's Hospital at RAF Halton, near Wendover in Buckinghamshire, Squadron Leader David Matthews restores the eyelid of an airman with a badly burned face. Local, rather than full, anaesthetics were used for this type of operation. The nursing sister has put her hand on the airman's.

Back in 1939 Matthews had helped Sir Archibald McIndoe establish his famous pioneering plastic surgery hospital at East Grinstead, and during the war he wrote *The Surgery of Repair* (1942), the first textbook on reconstructive surgery.

Alfred Thomson has given prominence to the ceiling-mounted surgical light, perhaps having learned from the surgeon about the state-of-the-art nature of RAF Halton's operating theatre. Dating from 1927, it was still relatively new, and Matthews and his team would have appreciated its modern elements, replacing earlier theatres which were simply located on upper floors and lit with skylights.

Alfred R Thomson

Aircraftman First Class J D S Gordonu, RAF Halton

(1943)

Oil on canvas, 59.7 x 49.5 cm
RAF Museum FA02932

We know frustratingly little about Aircraftman Gordonu, except that he was one of around 50 Nigerians who volunteered for the RAF. We also know that he served with RAF Balloon Command as he appeared in the Colonial Film Unit's 1940 propaganda film, *This is a Barrage Balloon.* Gordonu's pensive demeanour suggests homesickness – understandable in this young man so many thousands of miles from home.

Attitudes to Black RAF recruits were complex. After an initial wave of enthusiasm, the Air Ministry in March 1941 decided to 'slow down' the recruitment from West Africa, and news of this must have been deeply unsettling for those who had made the journey to serve what they regarded as 'the Motherland'. There was genuine warmth within some aircrew, but also overt hostility, and Gordonu may have encountered this, especially as working on a barrage balloon site very likely meant living in a remote location where Black people were rarely seen.

Back in Gordonu's homeland, the war's demands were having a disastrous effect on the Nigerian economy, with some communities experiencing hunger on account of the forced requisition of foodstuffs. The war ended up fuelling demands for independence across the Empire.

Alfred R Thomson

A Saline Bath, RAF Hospital

(1943)

Oil on canvas, 111.7 cm x 86.3 cm
ART LD 3629

The speedy transfer of a pilot to a specialist hospital like that at RAF Halton could mitigate the massive fluid loss and shock arising from severe burns, and saline baths like these were a vital part of their treatment. They had first been tried out at Archibald McIndoe's pioneering burns unit in East Grinstead in 1940, where the surgeons had realised that burned pilots who had spent long periods in the sea had a faster rate of healing. Thomson's painting captures the cautious intervention of the masked nurse, and the vulnerability of the airman, contemplating his extensive burns and charred, misshapen feet.

We do not know the circumstances in which Thomson was allowed to sketch and paint this scene. He appears to have spent several weeks at RAF Halton and must have gained the trust of both medical staff and patients during this time.

A letter in the WAAC correspondence towards the end of 1943 suggests that the Air Ministry were dissatisfied with Thomson and wanted Clark to speak to him about the quality of his work. It is hard to know what prompted the Committee's concerns. The Air Ministry may have disliked the topics Thomson chose while at RAF Halton, or the time Thomson spent at the hospital – with its deeply troubling sights – may have taken its toll on him.

Elsie Dalton Hewland

Assembling a Hawker Hurricane

(1943)

Oil on canvas, 45.7 x 60.9 cm
Manchester City Art Gallery 1947.402 © Manchester Art Gallery /
Bridgeman Images

Elsie Hewland had trained at Sheffield School of Art and later spent
four years at the Royal Academy Schools. In 1943 she was living in
Chalfont St Giles, Buckinghamshire, and would have been aware of the
aircraft being test-flown at the nearby vast Hawker Aircraft Company
airfield at Holmwood, near Slough. Here Hewland has produced
a painstaking rendition of the last stages in the construction of a
Hurricane, when the tubular steel frames are checked before the metal
panels are affixed.

Hewland asked the WAAC whether she could have permission to
sketch at RAF Bovingdon, also local to her home and taken over in
1942 by the United States Army Air Force. The WAAC were doubtful,
but they did make the request, and Hewland was issued with the
necessary pass, though whether she actually painted there is unclear.

Dame Laura Knight
Take Off

(1943)

Oil on canvas, 182.8 x 152.4 cm
ART LD 3834

In July 1943 Dame Laura Knight was commissioned to create a large painting of a bomber crew and went to RAF Mildenhall in Suffolk, where four airmen posed for her in the cockpit of a Short Stirling bomber. It seems likely that the airmen explained their roles in some detail to Knight, so that she could accurately capture the moments before take-off.

In this scene, the pilot and flight engineer are performing their final checks in the cockpit, while the navigator plots their course on a map and the wireless operator takes his final instructions from the ground. We see the bulky attire and equipment the airmen wore: leather jacket and helmet, oxygen mask and microphone, Mae West and parachute harness. In the foreground, Knight shows us the wireless operator's silver leather gloves. The leather provided a defence against icy temperatures, while the silver would shed vital light on knobs and switches if other sources failed.

Weather patterns, tracked back in the UK, could lead to the pilot having to divert, and it was the wireless operator who would pass on this vital information. He also assisted the air gunner by scanning the skies for enemy aircraft, using the aircraft's intercom to alert the gunner if they were spotted. The wireless operator's most crucial role though came if the pilot decided to ditch into the sea. Fast transmission back to the UK of their exact position could mean the difference between being rescued or left adrift at sea in a dinghy with little hope of surviving.

In 1945 Knight learned that Flight Lieutenant Ray Escreet, one of the airmen in her painting, had been shot down and killed. The son of a greengrocer in the Yorkshire seaside town of Withernsea, Escreet was one of hundreds of RAF wireless operators who took part in bomber raids. (He posed as the navigator in this painting – the figure on the left.) Knight asked for three enlarged photographs of her painting to be sent to Escreet's mother. Later it became known that his last flight had been from the top-secret RAF Tempsford in Bedfordshire, from where agents were flown and parachuted into occupied Europe.

147

Leslie Cole
Air Transport Auxiliary
(1943)

Oil on canvas, 59.9 x 90.4 cm
Sheffield Galleries and Museums Trust, UK, VIS. 1808,
© Sheffield Museums Trust / Bridgeman Images

'Do you think it will be worth chasing that ATA permit out of MAP just in case?' Leslie Cole asked the Committee in November 1942. Cole was rewarded when the permit came through from the Ministry of Aircraft Production, allowing him to produce this quirky, stylised depiction of an Air Transport Auxiliary pilot being fitted with her parachute harness.

These pilots had to be adept at learning the intricacies of different aircrafts' controls. They played a vital role in relieving RAF pilots for other work. From 1943, unusually for the time, women pilots received equal pay to their male counterparts. One of their number was Amy Johnson, the pioneer aviator, who was killed when her Airspeed Oxford went off course in bad weather and crashed.

Ethel Gabain

A Bunyan-Stannard First-Aid Envelope for Protection Against infection in Burns: as Issued to the RAF, 1943

(1943)

Oil on panel, 63.5 x 76.2 cm
ART LD 3849

In November 1943 the latest WAAC Secretary, Eric Gregory, wrote to Air Marshal Sir Harold E Whittingham, Director General of RAF Medical Services, to ask whether the artist Ethel Gabain might have special access to RAF Hendon. There Gabain painted this oil showing how a medical advance – an envelope made from coated silk – could aid a burned aircrew's safe return.

In the first image, the pilot winds a bandage onto his hand, holding the fastening between his teeth. In the second, the air gunner has injured both hands but is still able to continue to shoot. In the third, the pilot's bandaged fingers work the flight instruments in the cockpit. In the fourth, the navigator can still plot the plane's course on his maps. Bunyan-Stannard irrigation envelopes were the invention of surgeon John Bunyan, who reported their value in the *British Medical Journal*, mentioning in particular one William Stannard, a wholesale fabrics manufacturer in the Staffordshire town of Leek, who worked with Bunyan for eight months to perfect their joint innovation.

Gabain's RAF hosts at Hendon were especially accommodating, bringing her a film so that she could see the whole process, and even suggesting that she might take a flight for greater authenticity. This request got referred to Air Ministry Public Relations, who were not pleased. Gregory, new to the job, had not gone through the proper channels, and received a testy letter. 'How she obtained a permit to visit Hendon is nobody's business,' wrote Staff Officer Blackborow, adding 'I cannot see any reason why she finds it necessary to go into the air at all'.

Ruskin Spear
In the Dope Shop of an RAF Mosquito Aircraft Factory
(1943)

Oil on canvas, 72 x 92 cm
Rugby Art Gallery and Museum RC040 © Mrs Mary Spear

Well known for his depictions of pubs and the working-class community in Hammersmith, Ruskin Spear had produced a number of paintings of London life for the WAAC. This painting was very likely done at the Standard Motors Facility at Ansty in Coventry, now given over to aeroplane manufacture. Women in overalls are applying 'dope' – cellulose paint – to the Mosquitos' linen surfaces.

The red liquid is drying on the fuselages of the aircraft but also seems to have pooled on the shed's floor. It contained Benzene, known to be a carcinogen, and there were sufficient concerns at the time for a safety investigation to be undertaken in factories in Yorkshire, Hertfordshire and Surrey. This involved sampling workers' blood and urine and assessing to what extent air quality was improved by ventilation (not evident in this painting).

The dangers of Benzene had been known since 1897, and the report's authors pointed out the well-known risks of leukaemia, and that it was hard to avoid inhaling in a situation where the women stood constantly over the surfaces. They nonetheless concluded that no significant risk to health could be established and mentioned that the factory workers themselves were scornful of the idea that there could possibly be a hazard.

1944

Alfred R Thomson

Group Captain P C Pickard, DSO and Two Bars, DFC and Flight Lieutenant J A Broadley, DSO, DFC, DFM

(1944)

Oil on canvas, 91.4 x 71.1 cm
ART LD 3814

By the time this portrait was finished, Percy Pickard and his navigator, John Broadley, had become legendary figures in the air war. Pickard had starred in the 1941 film *Target for Tonight*, with his Vickers Wellington bomber, known as *F for Freddie*, becoming a household name. The following February 1942 he and Broadley had led the squadron of Whitley bombers that had dropped the paratroopers who carried out the Bruneval Raid in northern France, resulting in the capture of vital German radar equipment.

In February 1944 Pickard and Broadley led the attack on Amiens Prison – an effort to prevent the execution of resistance workers held there, flying at tree-top height in order to achieve accuracy in a situation where the prisoners themselves might be killed. As they circled to check on the results of the raid, Pickard and Broadley's Mosquito was shot down and both men were killed. Their deaths were not publicised until September of that year.

Rupert Shephard

A Nose Section After Repair: Girls Fitting Supports to Take the Bomb-Aimer's Window

(1944)

Oil on canvas, 60.3 x 50.1 cm
ART LD 4141

These mechanics are repairing the nose section of a Lancaster bomber at the Avro Repair Organisation at Bracebridge Heath, close to RAF Waddington, the bomber base just south of Lincoln. As the prospect of an Allied invasion of mainland Europe loomed, repair shops went into overdrive to meet the demand for serviceable aircraft.

Rupert Shephard had attended the Slade at the age of 17, and then taught art at Raynes Park County School, Merton. From 1937 to 1939 he exhibited with the founding members of the Euston Road School. When war broke out, he started to work in an aircraft components factory and began to submit drawings of the factory and their processes to the War Artists Advisory Committee (WAAC), eventually persuading the Ministry of Supply to give him time off to paint.

When interviewed about his career by the Imperial War Museum in 1978, Shephard remembered the training he had received at the Slade, where the legendary Henry Tonks taught his pupils to draw like the old masters, and how there was a 'gap between what you were taught at the Slade and what you saw in the Bond Street galleries'. He also said that it had been growing up in London – 'much greyer and foggier than it is now' – that had produced his customary subdued palette.

Alan Sorrell

Airmen's Billet: LAC Jones Suddenly Realises that To-morrow is not Payday

(1944)

Ink wash and chalk, 47.7 x 38.8 cm
ART LD 4220

Leading Aircraftman Jones looks moodily out of the window, wondering how to fill his day off. Alan Sorrell depicts the boredom that living in remote rural locations could inflict on young men, especially when they had little money for fares, pub or cinema. The floral wallpaper suggests the airmen are staying in a private home, just possibly the servants' quarters of Bradwell Lodge, where we know Sorrell spent some time.

Sorrell's work reminds us of the thousands of low-ranking ground crew who worked to support those on operations: fitters, mechanics, riggers and electricians. 'It may be considered depressing, but it's genuine,' Sorrell told Eric Gregory, adding in another letter that it was 'an extremely truthful piece of recording and would strike a chord in many an airman's heart'.

Rupert Shephard

Filming a Practice Launching of a Rubber Dinghy in a Training Pond

(1944)

Oil on canvas, 55.8 x 75.2 cm
ART LD 4647

The location of the 'training pond' is not given in the title, but Rupert Shephard's painting in fact shows the filming at Pinewood Studios by the RAF Film Production Unit of the closing scenes of *Journey Together*, the famous 1945 feature film about a bomber crew. Directed by John Boulting, and scripted by Terence Rattigan, the film starred Richard Attenborough, Jack Watling and David Tomlinson, all actors who had served in the RAF.

In March 1944, the WAAC were alerted by the artist George Quarmby to the potential of Pinewood as a topic for a painting. Quarmby recommended in particular the large 'pond' used for the filming of the bomber once it had ditched into the sea. Shephard was duly despatched to Pinewood.

Film cameras whir as the actors drag the inflatable dinghy from the rapidly-sinking Avro Lancaster. A mechanical wave machine is being vigorously worked by the men on the left. The figure with the megaphone is very likely the film's director, Flight Lieutenant John Boulting, and the seated woman with the script 'continuity girl' Leading Aircraftwoman Doreen North.

Mervyn Peake

Studies of Bomber Crew at Interrogation, 3am

(1944)

Charcoal and sanguine crayon, 50.6 x 69.7 cm
ART LD 6360 e

At the end of 1943, Mervyn Peake went to see Kenneth Clark and Gregory, and suggested that he use up the remainder of his fee to make drawings of the briefing and interrogation of pilots on return from operational flights. Clark agreed but seems to have been nervous of what Peake might produce, asking him to paint just two to three pictures before undertaking the full ten.

It is unclear where Peake went for this assignment. The WAAC minute suggests that he was sent to an airfield within No. 4 Group, which would indicate one of the stations in Yorkshire, but Peake's wife Maeve Gilmore's memoir recalls that it was in Sussex. Peake's annotations indicate that the crew were members of a Handley Page Halifax bomber crew.

Mervyn Peake
1944

Mervyn Peake

Off-duty Member of a Bomber Crew, Asleep, 1944

(1944)

Ink wash and crayon, 37.8 cm x 55.6 cm
ART LD 6362 © The Estate of Mervyn Peake

With a delicate touch, Peake shows an exhausted airman sleeping on a makeshift bed, getting some rest before the crew are assembled for interrogation. Given what the men had been through, for Peake to sit and draw them asleep might have felt like an unwarranted intrusion and suggests that someone arranged for him to have full and unfettered access.

Mervyn Peake

Bomber Crew Members at Interrogation

(1944)

Crayon, ink and gouache, 39.4 x 44.5 cm
ART LD 6367 © The Estate of Mervyn Peake

Two members of the crew drink coffee in the Operations Room, where an intelligence officer listens to their accounts of their mission. We know from Peake's caption that it was 3 in the morning.

The intelligence officer would have wanted to know about the route followed, what landmarks they had identified to guide them to their objective, the length of time over their target, the opposition they had met and what they had been able to see of the impact of their bomb loads on their targets. All too often aircraft failed to return, leaving crew who had arrived back safely hoping that their fellow airmen might have bailed out and become prisoners of war.

Mervyn Peake

Interrogation of Pilots

(1944)

Oil on canvas, 91.2 x 127.7 cm
ART LD 4528

Returning to London in the summer of 1944, Peake drew on his earlier sketches and drawings to work up this oil – the primary focus of the 1944 commission. The V1 flying bomb attacks had just begun ('flying robots' as he described them in a letter to Maeve Gilmore) but Peake continued to paint in his studio in Chelsea. Letters to Maeve suggest that he had lost enthusiasm for the WAAC assignment: 'I am going to put a solid days work on the RAF thing. Once I am free of that I will feel better and more creative.' The arrival of the proofs of his novel *Titus Groan* at the start of August probably did not help. Peake eventually submitted the painting, receiving £82 10 shillings for all of his RAF works in September that year.

In the gloom of the briefing room, its walls lined with maps, Peake captures the mood of the exhausted men as, still wearing their fur-lined boots, they tell their story to the squadron intelligence officer. 'Pilots' must have been Peake's shorthand for the aircrew, who in fact comprised the pilot, flight engineer, navigator, bomb aimer, wireless operator and rear and mid-upper gunners.

Thomas Monnington

Southern England, 1944. Spitfires Attacking Flying-Bombs

(1944)

Oil on canvas, 105.4 x 143.3 cm
ART LD 4589

Thomas Monnington initially joined the Directorate of Camouflage at Leamington Spa in 1939, but in 1943 wrote to the WAAC seeking work. Willoughby de Broke thought that Monnington had 'the right ideas' and fixed for him to visit RAF Marston Moor in the South Pennines, where training on heavy bomber aircraft was taking place.

Monnington, like many of his class, had done quite a lot of amateur flying before the war and was now determined to see some action. He found it difficult to capture actual combat, however, and his failure to deliver became an issue for the WAAC. 'The trouble with this artist,' Gregory complained privately to the WAAC's finance officer, 'is that he needs a lot of preparation before he can start a picture'. Here Monnington shows three Spitfires working in unison to deflect a V1 flying bomb – a tactic which reduced the number of explosions over the densely populated capital.

Paul Nash

Battle of Germany

(1944)

Oil on canvas, 121.9 x 182.8 cm
ART LD 4526

'If it comes off it might be the best thing I have done of any kind' wrote Paul Nash to Clark in September 1944. The third painting in the series relating to the air war – originally conceived back in 1941 – had been slow to materialise. The large canvas installed in 1940 in the Woburn Place studio was at one stage earmarked for it, but when, in 1942, Nash came to outline his idea for 'a large bombing invasion of Germany picture' to Willoughby de Broke, the latter had gone into what Nash described as 'a strong rearguard action'.

The Committee eventually approved the idea, and in May 1944 Nash put a number of requests to the Air Ministry. They duly undertook to find him 'an intelligent airman who has had experience of night bombing over Germany' who could visit him in Oxford. They sent him aerial photographs of Berlin under fire and arranged for three spools of RAF film to be copied by Wallace Heaton, the film specialists on New Bond Street. Nash's health was now failing – he felt 'exhausted and witless' – but delivered the finished work in late September, enclosing his now customary explanation of its content:

'...The moment of the picture is when the city, lying under the uncertain light of the moon, awaits the blow at its heart. In the background, a gigantic column of smoke arises from the recent destruction of an outlying factory which is still fiercely burning. These two objects pillar and moon seem to threaten the city no less than the flights of bombers even now towering in the red sky. The moon's illumination reveals the form of the city but with the smoke pillar's increasing height and width, throws also its largening shadow nearer and nearer. In contrast to the suspense of the waiting city under the quiet though baleful moon, the other half of the picture shows the opening of the bombardment...'

Clark did not react well: 'I can only tell you truthfully my own feelings in front of it which were apologetic bewilderment and incomprehension.' Nash's dismay may well be imagined, but three weeks later a further letter arrived. Clark now considered *Battle of Germany* 'a beautiful work and a very clear piece of design' and suggested that Nash think of 'other war subjects, the more experimental the better, at this stage'. Again Clark had sat on the fence, unwilling to defend a bold rendition of the bombing of Germany for fear of disapproval from the Air Ministry. Nash now moved onto other topics: the landscapes of north Oxfordshire and, in particular, the mystical Wittenham Clumps – wooded hills he had known since his youth.

There is a postscript to *Battle of Germany*'s story. In the James Bond 2021 film *No Time To Die*, the painting can be seen hanging on the office wall of MI6 chief Gareth Mallory – played by Ralph Fiennes – the backdrop to the film's close-to-final, poignant scene.

Albert Richards
Loading Containers on a Dakota Aircraft

(1944)

Oil on panel, 55.5 x 75.5 cm
ART LD 4178

Albert Richards had trained at Wallasey School of Art and won a scholarship to the Royal College of Art, spending just one term there before the war interrupted his studies. Richards enlisted in the army and continued to paint 'under trying conditions', submitting work to the WAAC, who began to make regular purchases from him. In spring 1943, Richards transferred to a parachute squadron in the Royal Engineers, writing to Gregory of the 'beautiful experience of parachute descents'.

The events recorded here took place at RAF Broadwell in Oxfordshire on 5 June 1944 – the eve of D-Day, the Allied invasion of Normandy. Canisters containing ammunition are being loaded onto the transport plane that will take off that evening for France. Richards wrote to Gregory: 'In a few hours' time I start upon my job as official war artist... and I feel that I will really be fulfilling the task set out to do, to produce paintings of the war and not preparations for it... Tomorrow I shall be in France. The beginning.'

Albert Richards

The Landing: H Hour Minus 6. In the Distance Glow of the Lancasters Bombing Battery to be Attacked

(1944)

Graphite, crayon, gouache, watercolour and wax, 54 x 73.7 cm
Tate N05726, presented by the War Artists Advisory Committee 1946 © Tate

This was the scene that Richards witnessed as he descended into enemy terrain as part of the airborne assault that took place some hours before the D-Day beach landings on the Normandy coast. Richards depicts some of the one hundred Lancasters that attacked the Merville Battery, an important coastal fortification that had to be captured before the main landings took place.

He wrote to Gregory on 19 July 1944, 'I know the four watercolours I sent to you were much below what I expected of them. I was in a rather dazed condition when I painted them'. Richards needed to be away from the battlefield to fulfil his official artist role and was able to take a lift back to England on the planes repatriating wounded soldiers, giving himself much-needed quiet to concentrate on his work.

Albert Richards

A Night Scene in Normandy: La Délivrande

(1944)

Watercolour, 53.3 x 73 cm
ART LD 4235

Anti-aircraft fire rises from the village of Douvres in the Calvados region of northern France, where the Germans had installed their own response to the threat of the RAF: two heavily manned early warning stations, equipped with powerful Würzburg radars. A naval bombardment partially destroyed the stations, and there was bitter fighting to secure the village – one of several scenes witnessed by Richards. He wrote to Gregory that his mind was 'always full of pictures of my gallant Airborne friends who gave their lives so readily'. In March 1945, Richards was able to report to Gregory that 'slowly but surely we are edging into Germany'.

After seven months of being on active service, while also documenting the progress of the war, Richards was killed when he hit a mine while driving his jeep at night near the Dutch-German border.

Evelyn Dunbar

Section Officer Austen, Women's Auxiliary Air Force Meteorologist

(1944)

Oil on canvas, 50.2 x 76.2 cm
RAF Museum FA02904Y

Evelyn Dunbar had studied at Rochester School of Art, followed by Chelsea School of Art. Sir William Rothenstein had recommended that she apply to the WAAC at the start of the war, and she contributed around 40 works to the scheme.

In this painting undertaken at RAF Gravesend near her home in Rochester, Kent, Dunbar shows a WAAF meteorologist working on her charts. Being able to predict weather patterns was vital for the safety of aircrew, and here Section Officer Austen is analysing and mapping information from weather patrols. RAF stations were encircled in red and black ink, and the WAAF would note down the temperature, wind, visibility, pressure, cloud height and cloud types for each location.

Dunbar's husband Roger Folley was an RAF navigator and had been on active service in Normandy, and she would have known of the importance of meteorologists' work.

1945

Alan Sorrell

RAF Station: New Arrivals at the Guard Room

(1945)

Pastel, 34.6 x 51.4 cm
ART LD 5404

By 1945 Alan Sorrell, having been promoted from leading aircraftman to 'the grandeur of corporal', had applied for leave from the RAF so that he could undertake a visual record of Air Ministry buildings for its historical branch.

Sorrell's ability to conjure the atmosphere of air stations matures in this scene, and, with time away from work, he is able to recreate the mood of the busy hutted encampment, playing with both the moonlight and the light from the interiors of the Nissen huts, and the competing textures of wooden duckboards, metal huts, taut cables, silhouetted trees and billowing smoke.

Tom Gourdie

*De-icing Before a Strike off the Norwegian Coast during which
this Beaufighter was Lost*

(1945)

Oil on canvas, 45.5 x 60.7 cm
ART LD 4968

Tom Gourdie initially left school at 16, but later returned and gained
a scholarship to Edinburgh College of Art, after which he worked for
a time for the mapmakers Bartholomew. He joined the RAF in 1940
and began working as an airman schoolmaster at RAF Dumfries. Eric
Kennington recommended him to the War Artists Advisory Committee
(WAAC), but despite this, no work was offered. Gourdie continued to
send work to London, apologising that 'there's nothing monumental
about any of them' and that none 'were particularly warlike'. It is
tantalising to realise what the WAAC missed. Gourdie mentions in a
letter 'a trifle painted in the Night Scotsman one night in June of 1943',
portraits of Norwegian airmen and a scene of women making wartime
grade paper from straw in a papermill in Fife – topics which were very
much in line with the WAAC's approach.

 In the end, the WAAC bought just one painting from Gourdie. Early
1945 found him at RAF Dallachy on the Moray Firth, where Bristol
Beaufighters were being used to attack German shipping off the
Norwegian coast. When he sent in this oil painting, Gourdie explained
that it had a tragic significance:

'I drew the scene depicted on the spot (it was very, very cold!) and put
in the Pilot and Observer as they walked to the plane. The pilot was
W/O Leslie and the Navigator was a friend of mine, F/O Heffernan,
from New Zealand. They went off to Norway and did not return.'

In the closing weeks of the war Gourdie sent the Committee more of
his work, but none was accepted.

Alan Sorrell

FIDO in Operation

(1945)

Watercolour and gouache, 37.4 x 48.8 cm
ART LD 5593

Here Alan Sorrell shows one of the more bizarre inventions to come out of the Second World War. Coal-fired factories and the widespread use of coal for heating at this time meant that fog was a major hindrance for aircraft returning from missions. In desperation to reduce the number of crash landings among returning bombers, the Minister of Petroleum was detailed to find a solution and responded with Fog, Intensive, Dispersal Of (FIDO). This novel scheme involved inserting pipes along airfield runways and pumping petrol through them which, once lit, produced intense fires which dispersed the fog.

FIDO consumed huge amounts of petrol, but saved thousands of aircrews' lives. For the pilots though it was 'a little like landing into the mouth of hell'. Pilots were initially concerned at the risk of veering off the runway and being engulfed in flames, but soon accepted that the promise of a safe landing outweighed this.

1946

Alan Sorrell

Construction of a Runway at an Aerodrome

(1946)

Oil on canvas, 66.5 x 188.5 cm
ART LD 5674

With demobilisation under way, airmen and WAAFs took their leave of the bases they had come to know so well. Alan Sorrell visited both RAF Tuddenham in Suffolk and RAF Marham in Norfolk around this time, capturing the detail he needed for his last contribution to the scheme – this valedictory, textbook rendition of the standard 'Class A' airfield which had been so crucial to the air war.

Sorrell depicts with precision the various elements whose evolution he had witnessed: the three long intersecting runways, designed to allow safe take-off and landing in different wind directions; the concrete perimeter track; the 'hard stands'; and, in the distance, the regulation 'T2' hangar which Sorrell had seen built in such large numbers. A farmhouse sits in the centre of the triangle – a reminder of the dislocation caused to rural communities by the scale and relentlessness of the airfield building programme.

William Dring

Squadron Leader L H Trent VC DFC

Pastel, 67 x 54.4 cm
ART LD 5832

With the end of the war, airmen who had been captured and become prisoners of war made their way back to England.

New Zealand-born Leonard Trent had flown numerous photographic reconnaissance and bombing missions. In May 1943 he and his navigator had been the sole survivors when their aircraft was brought down during a daylight attack over a steelworks factory in the Netherlands and Trent had become a prisoner of war in Stalag Luft III in Lower Silesia. The prisoners there devised an elaborate plan to escape, involving the construction of three tunnels. This scheme – later known as 'the Great Escape' – had a tragic ending when, following the escape of 76 airmen, 73 were recaptured, 50 of whom were shot in reprisal. Trent had exited the tunnel, but had been recaptured immediately, so was spared the retribution meted out to his fellow prisoners of war.

We do not know what conversations took place between artist and sitter, but it is likely that Trent told William Dring these facts, and of his experiences in the weeks before his repatriation in May 1945, during which he survived a brutal forced march.

Julius Stafford-Baker

Nuremberg: All That is Left of the Commercial Centre after Heavy Raids by the RAF

Watercolour, 54.6 x 76.2 cm
ART LD 5723

Civilians walk through the shattered remains of the old town of Nuremberg, the city in the south of Germany which suffered numerous devastating air raids. The most intense took place on 2 January 1945 when 1,835 of the city's inhabitants were killed and over 4,000 buildings destroyed. Even today unexploded bombs are found in the city.

The War Artists Advisory Committee purchased numerous watercolours from Julius Stafford-Baker, whose works provide a detailed record of the closing months of the war in Italy and Germany. In 1945 he was with British forces when they entered Berlin after the city's surrender to the Soviets, and later visited Nuremberg to cover the war crimes trials taking place there.

Afterword

On 11 July 1946, Paul Nash died. He had confided to his friend Gordon Bottomley that he had been worn out by his work on the air war. The War Artists Advisory Committee (WAAC) gradually wound up its work, distributing the 6,000 paintings it had accumulated to museums and galleries across the UK, with just over half coming to the Imperial War Museum (IWM). Kenneth Clark resigned from the directorship of the National Gallery to pursue a career as a writer and broadcaster. E M O'R Dickey was one of the fortunate parents whose missing son – he had been captured after bailing out over Germany – made his way back to England after the war.

The WAAC had given opportunities to dozens of artists, extending their range. Paul Nash had shown that he could respond to the new conflict with his surrealist portrayals of aircraft. Eric Ravilious had found inspiration in flight in a way that no one familiar with his 1930s scenes of rural and coastal England could have predicted. Eric Kennington's output of heroic portraits, having done their work of celebrating airmen for the wartime population, were for several decades used in the IWM's narration of the Second World War – though are less often shown today. Leslie Cole continued to

teach but never again produced work of the same intensity; the post-war years could not deliver the opportunities. Alan Sorrell found a new direction as a prolific illustrator, reconstructing scenes of ancient and medieval Britain.

Dorothy Coke, whose witty renditions of servicewomen had caused such upset, taught at Brighton College of Art for many years, and was the subject of a retrospective in 2014, revealing the enthusiastic record she had made of that town. Tom Gourdie became an expert in calligraphy, writing several books on the subject. Mervyn Peake's *Titus Groan* was published in 1946 and became a literary sensation, its author hailed as a genius and the Gormenghast series eventually translated into 20 languages. Clark must surely have regretted that he had not given Peake more of the work he so fervently craved.

The RAF had played a decisive role in the outcome of the war and its history became firmly established in British cultural memory – the most lauded of the services, with films, books and television series embedding the record in the public's consciousness. In 1953 an immense white stone memorial was dedicated at Runnymede, overlooking the River

Thames. Engraved on it by name, country and rank were the names of over 20,000 airmen and airwomen who had been killed, but whose remains had never been recovered. Thousands more lay in cemeteries in Germany, France, the Netherlands or even farther afield. Debates went on for decades about the morality of bombing German cities, particularly Dresden, which had been so devastatingly attacked in the closing weeks of the war. For the thousands of men and women who had served in the RAF and the Women's Auxiliary Air Force or worked in balloon teams or aircraft factories, their lives would never again be driven by such a powerful sense of a common cause.

Today new generations of scholars excavate these and other questions: the later lives of aircrew; the experiences of the mechanics, riggers and fitters; the lives of Black airmen in RAF squadrons; the reality of what it was like to be burned and given newly evolved plastic surgery; the very mythologising of the air war. The artists featured here were constrained by the knowledge that they too were part of the war effort, playing their part in a conflict whose end was not yet in sight. Their 'reportage' was accordingly limited in scope. But there is an immediacy in what they created that highlights the complex nature of the struggle, its innate beauty and the intense toll it took. Through sheer zeal and discernment, the artists in this book bring us new truths about the air war.

The Artists

John Armstrong (1893–1973)

Born in Hastings, John Armstrong studied law at the University of Oxford, served in the First World War and became a designer of posters, theatre sets and costumes for films. He had his first one-man show in 1928 and later joined the Modernist group Unit One, founded by Paul Nash, which included Henry Moore, Barbara Hepworth and Ben Nicholson. Combining painting with commercial work, he was known for a series of posters commissioned by Shell and the General Post Office, and also designed ceramics, including some for the ceramic artist Clarice Cliff. His 1940 work *Can Spring Be Far Behind?*, showing a single tulip rising from a devastated city, was originally intended to be a propaganda poster, but was considered too poignant and was not used.

In 1955 he completed a ceiling mural for Bristol City Hall's Council Chamber which, filled with sailing ships, illustrates the city's maritime, industrial and archaeological history. His work *Pro Patria* (1938) was purchased by the IWM in 1995 with support from the National Art Collections Fund (later the Art Fund).

John Berry (1920–2009)

John Berry won a scholarship to the Royal Academy at the age of 19, but the outbreak of the war put an end to this hard-won opportunity. After training as a radar operator,

Berry served in Africa with the Eighth Army. Asked by the padre to design a poster, his talent soon became known, and he began to paint in an official capacity. After the war, Berry became an illustrator for Ladybird books – a popular series that helped children with their reading. Berry was the sole illustrator of the 20-volume Ladybird series *People at Work*, which ran from 1962 to 1973.

David Bomberg (1890–1957)

David Bomberg was one of an influential group of Jewish artists later known as the 'Whitechapel Boys' – who painted the Jewish East End. After training at the Slade, he had his first solo show in Chelsea in 1914. During the First World War, he served on the Western Front and produced a work for the Canadian War Memorials Fund, *Sappers at Work* (1918–1919). From 1923 to 1927, he recorded scenes in Palestine, before travelling to Spain where he produced some of his most outstanding work. Greatly to his dismay, his many overtures to the War Artists Advisory Committee (WAAC) were initially rebuffed. Bomberg began teaching at Borough Polytechnic in 1945 and became the central figure in the influential Borough Group which flourished from 1946 to 1951. After his death, Bomberg's works began to be collected by major galleries. *Evening in the City of London* (1944) is owned by the Museum of London, and *The Mud Bath* (1914) depicting a communal bath in Brick Lane by the Tate, as is another painting of the bomb store. In 1979 an

exhibition of his work was held at the Whitechapel Gallery, and in 1988 the Tate held a major retrospective of his work.

Stephen Bone (1904–1958)

Stephen Bone was the son of Muirhead Bone, who, as the first official war artist during the First World War, had produced a large output of drawings of the Western Front, and joined the WAAC when it was set up in 1939. Trained at the Slade, Stephen Bone served as a camouflage officer from 1939 to 1943. Stimulated by what he had seen through this work, he wrote a lengthy memorandum to the WAAC in March 1942 about the 'rich subjects which once gone will never recur', such as 'a queer romantic lonely ravine,' which was about to become a factory, and the interior of a big concert hall filled with barrage balloons.

Towards the end of the war Bone visited northern Norway, recording what remained of the labour camps where Soviet prisoners of war had died in freezing conditions.

Evan Charlton (1904–1984)

Born in London, Evan Charlton studied at the University of London from 1923 to 1927, and at the Slade from 1930 to 1933. He took up a teaching position in Bristol in 1935 and became head of Cardiff School of Art in 1938. He left this post to become HM Inspector for Art in Wales – a post he held until 1966.

Dorothy Coke (1897–1979)

Dorothy Coke was born in Southend-on-Sea, and studied at the Slade. In the 1920s and 1930s, she exhibited widely, including at the Royal Academy, Royal Watercolour Society and the New English Art Club. She taught at Brighton College of Art from 1939 until 1963. The year after she retired, Coke made a large number of ink drawings and watercolours of Brighton Art School, the Romanesque Revival building on Grand Parade, which had served the school for a century but was now being demolished. Fishing huts, Brighton's terraces, the seafront and a Communist Party meeting on Brighton beach were among the scenes shown at a retrospective of her work in 2014.

Leslie Cole (1910–1976)

Leslie Cole trained at Swindon Art School and the Royal College of Art, where he studied mural painting, lithography and fabric printing. When the war broke out, he was working as an assistant lecturer in lithography at Hull College of Arts and Crafts. Cole joined the RAF but was discharged on grounds of ill health; instead, he began submitting works to the WAAC, hoping to get a commission. He eventually became one of the most travelled of the Second World War official artists, documenting events in Malta, Sicily, Normandy, Burma, Singapore and Greece as well as the UK. From 1946 to 1976, Cole taught at Brighton College of Art (later Polytechnic) and the Central School of Arts and Crafts.

Charles Cundall (1890–1971)

Charles Cundall studied at Manchester School of Art and won a scholarship to the Royal College of Art in 1912. The First World War interrupted his studies, and he was sent to the Western Front in 1915 and was wounded in his right hand during the Battle of the Somme. Cundall returned to the Royal College in 1918, and from 1919 to 1920 attended the Slade, before moving to Paris, and later spending time in Italy, with fellow artist Henry Rushbury. His early works included a number of large-scale panoramic scenes of a Chelsea football match, *Bank Holiday, Brighton* (1933) and *The Boulogne Express* (1929).

William Dring (1904–1990)

Born in Streatham, William Dring studied at the Slade between 1922 and 1925, and then taught at Southampton School of Art. With the outbreak of war he began sketching what he could see of barrage balloons over Southampton, but reported to Dickey in September 1940 that this had got him arrested and marched off for interrogation under armed guard. The WAAC files tell a story of both a falling out with his employers and also of his earnest efforts to be employed by the Committee, eventually gaining a series of full-time contracts, the last of which saw him working on portraits for the Air Ministry throughout 1944 and 1945. Both IWM and the National Maritime Museum have large numbers of his wartime portraits, mostly done in pastel.

Evelyn Dunbar (1906–1960)

The daughter of a Scottish tailor and a mother who was a gifted amateur artist, Evelyn Dunbar studied at the Rochester School of Art, followed by the Chelsea School of Art and then the Royal College of Art (1929–1933). Her first major commission was to paint murals for Brockley County School based on Aesop's Fables, which she did together with her former tutor Charles Mahoney. Encouraged to apply to the WAAC by William Rothenstein, Dunbar was given a series of contracts with the WAAC which lasted for most of the war, submitting in total 44 works, many of them relating to the work of the Women's Land Army. In August 1942, Dunbar married Flying Officer Roger Folley and included an image of her husband cycling along the High Street in Rochester in his RAF uniform in *The Queue at the Fish Shop* (1944). The first retrospective of her work, *Evelyn Dunbar: War and Country*, was held at St Barbe Museum and Art Gallery, Lymington, in 2006, and in 2015 an exhibition *Evelyn Dunbar: The Lost Works* took place at Pallant House Gallery, Chichester.

Richard Eurich (1903–1992)

Richard Eurich was born and brought up in Bradford and attended Bradford School of Art, later recalling how he was inspired in his youth by a local Jewish sculptor and painter who had shown him art books she had brought back from Germany. He went to the Slade in 1925, where fellow students included Rex Whistler, William Coldstream and Stephen Bone. Following a one-man show at the Goupil Gallery when he was just 26, Eurich was given regular shows for many years at The Redfern Gallery run by the art collector Rex Nan Kivell. A lengthy correspondence with the novelist and translator Sydney Schiff offers insights into both Eurich's ambition to excel and his frequent self-doubt: 'I try to "live" myself into the subjects so as to get the truthful human side as far as possible', he wrote.

His work for the WAAC was well received, and he became a salaried war artist in 1943. Other major works Eurich contributed to the scheme were *Withdrawal from Dunkirk* (1940, Royal Museums Greenwich), *Night Raid on Portsmouth Docks* and *The Landing at Dieppe* (1941 and 1942–1943, Tate) and *Fortresses over Southampton Water* and *Preparations for D-Day* (1944, IWM) The WAAC minute for August 1944 recorded 'it would appear that this artist has managed to get across to Normandy'.

Eurich's reputation continued to grow in the post-war years, and he produced numerous inventive, almost mystical, works that are often rich in incident. An exhibition of his wartime paintings was held at the IWM in 1991.

Barnett Freedman (1901–1958)

The son of Russian-Jewish émigrés, Barnett Freedman was bedridden for many years in his youth but, as he told the WAAC in his biographical summary, it was in hospital that he had learned how to read, write, play music, draw and paint. He

started work aged 15 as an office boy, later becoming a junior draughtsman and taking evening classes at Saint Martin's School of Art. He won a scholarship to the Royal College of Art, studying there from 1922 to 1925. A period of extreme poverty followed as he struggled to find work as a commercial artist, but a breakthrough came when he was commissioned by Faber & Faber to design and illustrate Siegfried Sassoon's *Memoirs of an Infantry Officer* (1930). He went on to illustrate a six-volume edition of *War and Peace* (1938), as well as other books and numerous posters. After returning from France in 1940, Freedman served as a war artist with the Admiralty on Arctic convoys, and later recorded the D-Day landings. An exhibition *Barnett Freedman: Designs for Modern Britain* was held at Pallant House Gallery, Chichester in 2020.

Ethel Gabain (1883–1950)

Ethel Gabain was born in Le Havre, the daughter of a French coffee importer. She studied at both the Slade and the Central School of Art and Design, and in 1908, together with her future husband John Copley and Archibald Standish Hartrick, co-founded the Senefelder Club, which promoted the art of lithography. A portrait of Sir Alexander Fleming, and another of a child injured by a bomb being treated by the penicillin that Fleming discovered, are among the works by Gabain held by IWM.

Tom Gourdie (1913–2005)

The son of a miner, Tom Gourdie left school at the age of 15 to work in the Fife Coal Company's architect's office. He returned to school, and won a scholarship to Edinburgh College of Art, following which he spent some time with the mapmakers Bartholomew. In 1940 Gourdie joined the RAF and became an Airman Schoolmaster at RAF Dumfries. A number of artworks from his time there are in Kirkcudbright Galleries. After the war he studied for a teaching diploma and moved first to Banff Academy and then Kirkcaldy High School where he taught art for the rest of his career, becoming an authority on calligraphy and publishing a number of books, including *The Puffin Book of Handwriting* (1980) and *Calligraphy for the Beginner* (1982).

Frank Graves (1913–2001)

Born in Dublin, Frank Graves attended Belfast Art School and, after a period in Paris, moved to England to become a scenic artist with Ealing Film Studios. With the outbreak of war, Graves joined the Entertainments National Service Association (ENSA), based initially in Britain, and then moved to Cairo from where he travelled around the Middle East recording ENSA's performances and activities behind the scenes. After the war, Graves worked at Elstree, Pinewood and Shepperton Studios on a variety of film productions.

Keith Henderson (1883–1982)

Brought up in London, Keith Henderson left Marlborough College 'as soon as his parents would allow' to study at the Slade and then the Académie de la Grande Chaumière, Paris. During the First World War, he served on the Western Front, writing illustrated letters home to his wife which were later published as *Letters to Helen: Impressions of an Artist on the Western Front* (1917). In the 1920s and 1930s, Henderson travelled widely and worked as an illustrator, designing book jackets and posters for London Transport as well as scenes of West Africa, Cyprus and Burma for the Empire Marketing Board.

His painting showing an airman jumping up and down on the wing of a Lockheed Hudson, to test its undercarriage, is credited with causing the termination of his contract, but his overly colourful descriptions of RAF Leuchars in the magazine *The Listener*, and his witty but indiscreet letters to the WAAC, may not have helped.

Elsie Hewland (1901–1979)

Elsie Hewland studied at Sheffield College of Art from 1921 to 1924 and then at the Royal Academy Schools between 1926 and 1930. Besides her works depicting aircraft manufacture, Hewland also contributed paintings to the WAAC of schoolboys driving tractors and a nursery for children affected by the Blitz. In her biographical notes for the WAAC she mentioned that for some months in 1940 she taught handcraft work to the soldiers at her local hospital. She added that 'owing to duties at home I am unable to join the services, but give all available time to painting'.

Eric Kennington (1888–1960)

Trained at Lambeth School of Art, Eric Kennington enlisted in the army in 1914, and, from his experiences on the Western Front, painted *The Kensingtons at Laventie* (1915), a group portrait of his own infantry platoon, painted in reverse on glass – an exceptional technical achievement. Kennington contributed numerous pastels, charcoals and watercolours to the First World War official art scheme, and later sculpted the 24th Division War Memorial (1924) in Battersea Park, and three large stone figures of British soldiers on the Soissons Memorial to the Missing (1928). Kennington was closely associated with T E Lawrence, contributing portraits of Arab subjects to Lawrence's *The Seven Pillars of Wisdom* (1926).

Kennington's Second World War portraits were disliked in some quarters – 'Eric Kennington goes on and on with his over-life-size portraits of supermen,' wrote Eric Newton, 'they are strident things whose assertiveness almost hurts the eyes.' The criticism did not deter Kennington who had a strong belief that his works could serve as useful government propaganda. He eventually resigned from his commission with the WAAC, unhappy that his work was not being given the prominence it deserved.

Dame Laura Knight (1877–1970)

Born in 1877 in Long Eaton, Derbyshire, Laura Knight was the daughter of an art teacher and found her calling at an early age, enrolling at Nottingham School of Art aged just 14. Married to Harold Knight in 1903, the couple joined artistic communities first in Staithes, North Yorkshire, and then in Newlyn, Cornwall. Moving to London in 1919, ballet became Knight's major preoccupation, and she became well known for her paintings of dressing room interiors as well as circuses and travellers. Following her success as a popular artist, Knight was created a Dame in 1929, and published a memoir, *Oil Paint and Grease Paint*, in 1936.

Her output for the WAAC was substantial and included a number of portraits of WAAFs who had distinguished themselves in various ways, and large oils of barrage balloon repair and of the key Nazi perpetrators being tried in the dock at Nuremberg. Knight was the subject of a major retrospective at MK Gallery, Milton Keynes, in 2021.

Edwin La Dell (1914–1970)

Edwin La Dell attended Sheffield School of Art and from there went to the Royal College of Art, studying alongside Barnett Freedman, and in 1948 becoming Head of the College's Lithography department. Among his works in public collections is *The Crowd in the Mall, Coronation* (1953, Government Art Collection), showing crowds in the rain at Queen Elizabeth II's coronation.

Lowes Dalbiac Luard (1872–1944)

Born in Calcutta, Lowes Dalbiac Luard studied at the Slade alongside Augustus John and Ambrose McEvoy and established a practice as a portrait painter in London. He

lived in Paris from 1905 to 1934, where he painted the horses known as 'Percherons', which hauled timber along the River Seine. Later, during the First World War, Luard depicted similar horses pulling heavy guns through the mud of war-torn northern France. In 1932 Luard moved to London and for a time chose the backstages of circuses as his subject. During the Second World War, he served with his local Air Raid Precautions post and contributed to the WAAC a drawing of two rescuers cradling the head of a figure crushed by a beam – now in Manchester Art Gallery.

Frances Macdonald (1914–2002)

Frances Macdonald trained at Wallasey School of Art, between 1930 and 1934, before attending the Royal College of Art. She contributed 19 works to the WAAC. As well as the wrecked aircraft dump at Cowley, Macdonald was given access to the Mulberry Harbour caissons under construction in London's docks in preparation for D-Day. She also painted a portrait of Donald Bailey – inventor of the famous Bailey Bridge. After the war, Macdonald taught art at Goldsmiths, Beckenham and Byam Shaw Schools of Art.

Raymond McGrath (1903–1977)

Raymond McGrath studied architecture at the University of Sydney, and later attended Westminster School of Art. In 1930 he set up practice in London and became well known for his modernist designs, re-modelling a house in Cambridge in 1929, winning a prestigious architectural competition in 1930 and later joining the design team for the new BBC building at Portland Place. St Ann's Court in Surrey (1936–1937) was another highly regarded commission. Moving to Ireland in 1940, he became Senior, and then Principal Architect, in the Office of Public Works in Dublin.

Sir Walter Thomas Monnington (1902–1976)

The son of a barrister, Thomas Monnington studied at the Slade from 1918 to 1922 and then at the British School in Rome. He went on to teach and undertook commissions for St Stephen's Hall, Westminster and the Bank of England. Monnington's ambition to see action was fulfilled when in late 1944 he was attached to a squadron of American B-25 Mitchell bombers.

Monnington's marriage to the accomplished artist Winifred Knights ended in 1946, and she died suddenly the following year at the age of 48. After the war, Monnington returned to teaching at Camberwell School of Arts and Crafts and the Slade, contributing a fresco to Bristol City Council's new Council House in 1956. Monnington was President of the Royal Academy from 1966 until his death in 1976.

John Nash (1893–1977)

With no formal art training, John Nash began painting in oils with the encouragement of Harold Gilman, a founder member of the Camden Town Group, and, with his brother Paul, had a successful exhibition at the Dorien Leigh Galleries in 1913. From November 1916 to January 1918, John Nash served in the Artists Rifles, and on release from the army was employed by the British War Memorials Committee, producing several important works on the First World War. In May 1918, he married the artist Christine Kühlenthal, daughter of a German chemist. They set up home in the Buckinghamshire village of Meadle in 1921, remaining there until 1944. From 1924 to 1929, Nash taught at The Ruskin School of Drawing and Fine Art, and was in demand as an illustrator, producing many woodcuts and engravings for small literary presses. Nash lived to see his work shown in a retrospective at the Royal Academy in 1967.

Paul Nash (1889–1946)

Born in London, Paul Nash grew up in Buckinghamshire and studied art at several institutions, including the Slade. He was drawn to landscapes, and found rich subject matter among ancient sites, particularly the wooded chalk hills in Oxfordshire known as the Wittenham Clumps. Nash was elected to The London Group in 1914 and married Margaret Odeh in the same year.

With the outbreak of the First World War, Nash joined the army and was sent to the Western Front in February 1917 as a second lieutenant in the Hampshire Regiment. Invalided back to London that summer, he began to draw and paint, eventually producing several important works, including *The Mule Track* and *The Ypres Salient at Night* (both 1918). In April 1918, Nash, like his brother John, was commissioned by the British War Memorials Committee to paint a battlefield scene for the Hall of Remembrance project. The pair worked together in a makeshift studio at Chalfont St Peter, near the Nash family home, John producing *Over the Top* (1918) and Paul the large canvas now known as *The Menin Road* (1919), which captures the flooded trenches and rain-filled craters of the Ypres Salient.

Nash's arrival at the Royal College of Art was remembered by a pupil as 'like an explosion' – so dynamic was his teaching there. In the 1930s, he became a leading figure in British Surrealism, helping to establish the short-lived Unit One movement. The 1938 Venice Biennale included a retrospective of his work, featuring 16 oils and 11 watercolours.

Throughout the Second World War Nash remained 'passionately anxious...to strike a blow on behalf of the RAF' and produced a continuous stream of work, despite his failing health and awareness that his surrealist approach was out of tune with the WAAC's documentary mission. Nash was the subject of exhibitions at the IWM in 1988 and 1996, and a major retrospective at the Tate in 2016.

Mervyn Peake (1911–1968)

Born in Kuling, China, where his father worked as a missionary doctor, Mervyn Peake returned to Britain in 1923, studying for a time at Croydon College of Art, and then at the Royal Academy Schools. There followed a period on the Isle of Sark, as part of an artists' colony, established by his former teacher Eric Drake. In 1937 Peake married the artist Maeve Gilmore and began to have some success as an illustrator. With the outbreak of war, he was called up for service and spent much of 1940 on an anti-aircraft battery in Dartford, Kent, where he witnessed the Blitz at close hand. He sketched constantly during this period, but the works he produced were destroyed by bombing.

In his memoir *1945: The Dawn Came Up Like Thunder* (1983), the journalist Tom Pocock remembered Peake as 'a lean, slightly stooped man with black sprouting hair and a narrow, deep-lined face in which troubled eyes were set close'. 'One could sense,' he wrote, 'that he had been an appallingly helpless soldier.' The profound impact the war had on Peake can be read in his poem 'The Rhyme of the Flying Bomb' (1962).

One of the great literary figures of the twentieth century, Peake began to show signs of dementia when he was only in his forties; he went into decline, dying in 1968. An exhibition of his wartime work was shown at the IWM in 1990.

Eric Ravilious (1903–1942)

Eric Ravilious was born in Acton, where his father had a draper's shop. When the business failed, the family moved to Eastbourne, Sussex, where the young Eric, clearly talented, went to Eastbourne Grammar School and then Eastbourne School of Art. He subsequently attended the Royal College of Art, where he was taught by Paul Nash and became a close friend of Edward Bawden. In 1928 he worked with Bawden and Charles Mahoney on a series of murals for Morley College, which were later destroyed in the Blitz. He also undertook engravings for books, published by the Nonesuch, Curwen and Golden Cockerel Presses, and pottery designs for Wedgwood.

In 1930 Ravilious married Tirzah Garwood, living initially in London and then moving to lodge with Bawden and his wife Charlotte Epton at Great Bardfield in Essex. Visits to the artist Peggy Angus's cottage 'Furlongs' in Sussex gave Ravilious fresh subjects, and his works became sought after for their poetic, serene evocations of place. His 1940 *Train Landscape*, in which the Westbury White Horse can be seen from a third-class railway carriage, is just one of Ravilious's much-reproduced watercolours. Exhibitions of his work were held at the IWM in 1979 and 2003. The documentary *Eric Ravilious: Drawn to War*, directed by Margy Kinmonth, was released in 2022.

Albert Richards (1919–1945)

Albert Richards attended Wallasey School of Art. From there he won a place at the Royal College of Art, starting there in January 1940. Three months later he enlisted in the army and was soon building barracks and defensive works around the UK, sending paintings to the WAAC which they readily bought. He wrote to Dickey in April 1942 of the bitter conditions during the winter, when sappers had been building concrete defences using cold tubular metal scaffolding which stuck to their frozen fingers. 'Under these arctic conditions we lived and developed the defences of England.'

In September 1943 Richards had the opportunity of a three-month commission as a war artist but turned it down as he was training as a parachutist with the Royal Engineers, with the possibility of promotion and a commission. 'Now that life is more interesting I haven't the time to paint', he wrote to Eric Gregory in September 1943, adding 'But I have the beautiful experience of parachute descents to make up for it.' Following his death on active service in the Netherlands, Richards was buried in Milsbeek War Cemetery. There was a memorial exhibition of his work at the Walker Art Gallery, Liverpool, in 1948 and an exhibition at the Imperial War Museum in 1977.

Sir William Rothenstein (1872–1945)

William Rothenstein went to Bradford Grammar School, from where – aged just 16 – he went to the Slade. He had a long career which spanned teaching, writing, lecturing and gallery management as well as painting. Rothenstein regularly exhibited at the New English Art Club and was Principal of the Royal College of Art from 1920 to 1935. He liked to promote the work of others through recommendations and several of the artists in this book – including Barnett Freedman and Evelyn Dunbar – were given encouragement by him early in their careers. A retrospective, *From Bradford to Benares: The Art of Sir William Rothenstein*, was held at the Cartwright Hall Art Gallery, Bradford, in 2015.

Rupert Shephard (1909–1992)

As well as selling paintings to the WAAC scheme, Rupert Shephard worked part-time as a war artist attached to the Ministry of War Production, visually recording the war effort in industry, including interior views of factories manufacturing aircraft components and penicillin, and mechanics repairing Lancaster bombers in aircraft hangars. He contributed to *Recording Britain*, the scheme overseen by Kenneth Clark which invited artists to submit watercolours documenting the changes to Britain's landscape arising from the war.

After the war, Shephard taught part-time at the Central School of Arts and Crafts until 1948, when he was appointed Professor and Director of the Michaelis School of Art at the University of Cape Town. His decision was partly influenced by his wife, Lorna Wilmott, who had been born in South Africa. He returned to London in 1962 and, later widowed, married the artist and novelist Nicolette Macnamara Devas, whom he had known at the Slade. He later produced a number of linocuts of West London, in particular the World's End district of Kensington and Chelsea, and Putney, reflecting the social change of the time. His son, Ben Shephard, became a television documentary maker and a noted historian of the trauma and displacement that had occurred during and after the Second World War.

Alexander Sonnis (1904–1997)

Alexander Sonnis's parents were Jewish and migrated from Kamenets Podolsk, Ukraine, before settling for a time in London's East End. Sonnis worked part-time while studying at the Central School of Arts and Crafts. He told the WAAC that he had painted and drawn ever since his first memories, was very fond of music and played the flute as recreation. A textile designer for a number of years for the Manchester-based British Calico Printers Association, he was awarded a scholarship to the Royal College of Art in 1929. He then married the artist and sculptor Iris Cooke. After the war began, Sonnis enlisted in the RAF's Balloon Command in 1940, operating barrage balloons. In later life, Sonnis taught at a London school; he is remembered by his family for his vibrant, eclectic and colourful clothing style, and for a home lined with paintings, books and press cuttings.

Alan Sorrell (1904–1974)

Alan Sorrell grew up in Westcliff-on-Sea, Essex, where his father owned a jeweller's shop. He attended Southend School of Art, before winning a scholarship to the Royal College of Art. In 1928 he won the prestigious Rome Scholarship, allowing him to study the Renaissance murals of Italy, and spent a further two years travelling in Europe. He produced a series of murals for Southend Public Library on his return to the UK, as well as some remarkable paintings, including *A Land Fit for Heroes* (1936) – a piercing reflection on the cost of war.

Sorrell joined the RAF in December 1940, serving in the Central Intelligence Unit's model-making V- section first at Farnborough, and then at RAF Medmenham. He transferred to the Air Ministry in September 1941 becoming an airfield camouflage officer, returning to the RAF in 1944.

Sorrell contributed works to the WAAC throughout the war, struggling throughout to get sufficient time to draw and paint. His familiarity with aerial perspectives fed directly into his later career illustrating reconstructions of historic sites – castles, abbeys

and towns – as they would have appeared in Roman or medieval times. An exhibition, *Alan Sorrell: A Life Reconstructed*, was held at the Sir John Soane's Museum in 2013–2014.

Ruskin Spear (1911–1990)

Ruskin Spear was born in Hammersmith and given special schooling on account of an illness. He later recalled the small classes and excellent tuition he received with its emphasis on music – piano and violin – painting, chess, lettering and boot-making. He won a scholarship to Hammersmith School of Art, and another in 1931 to the Royal College of Art. During the war, Spear taught at Croydon School of Art, moving to the Royal College of Art in 1948 where he stayed until 1975. The WAAC saw Spear's strength as a painter of working people and he contributed works recording the efforts of both factory workers and dockers, and also a work *Deaf Girls Working on the Construction of Petrol Tanks* (1943). Spear was the subject of a retrospective at the Royal Academy in 1980.

Julius Stafford-Baker (1904–1988)

Julius Stafford-Baker served in the Royal Flying Corps in 1918 and joined the RAF Volunteer Reserve after its establishment in 1936. During the Second World War, he became an intelligence officer in the RAF, a role which entailed a great deal of travel – allowing him to paint watercolours of the numerous different places visited. Works owned by IWM include scenes at RAF Blida aerodrome in Algeria, of the invasions of Sicily and Italy, and of the closing months of the war in Germany and Poland, including the impact of bombing on Berlin and Warsaw.

Alfred Reginald Thomson (1894–1979)

Born in Bangalore, India, Alfred Thomson became totally deaf following a childhood illness. His father wanted him to train as a farmer, but he was determined to be an artist and, moving to London, studied at the London Art School in Kensington. In the 1930s, he designed a series of posters on the theme 'Then and Now' for the London and North Eastern Railway, splitting the poster diagonally to show how contemporary activities – golf, eating in restaurant cars, sea-bathing – were so different to those of the Victorian age. Thomson also painted murals, contributing scenes from Charles Dickens's *Pickwick Papers* to the Duncannon Hotel near Charing Cross (long-since demolished), and murals for the ocean liner RMS *Queen Mary* and the Chelmsford County Hall (both still viewable).

An unusual wartime commission was a large-scale portrait of a Soviet soldier, used as a backdrop at the Albert Hall for a fundraising concert to mark the 26th anniversary of the Red Army in February 1944. In the 1950s and 1960s, Thomson was commissioned by the Science Museum to paint murals of the histories of harvesting and astronomy as well as large oils showing dock scenes.

Sources

Select Publications

H E Bates, *How Sleep the Brave and Other Stories: Flying Officer X*, Jonathan Cape, 1943

Anthony Bertram, *Paul Nash: the Portrait of an Artist*, Faber & Faber, 1955

Helen Binyon, *Eric Ravilious: Memoir of an Artist*, The Lutterworth Press, 1983
© The Lutterworth Press

Jonathan Black, *The Face of Courage: Eric Kennington, Portraiture and the Second World War*, Philip Wilson, 2011

Hector Bolitho, *War in the Strand: A Notebook of the First Two and a Half Years in London*, Eyre & Spottiswoode, 1942

Christopher Campbell-Howes, *Evelyn Dunbar: A Life in Painting*, Romarin, 2016

Andrew Causey, *Paul Nash*, Oxford University Press, 1980

Mark Connelly, *Reaching for the Stars: A History of Bomber Command*, I B Tauris, 2001

Richard Cork, *David Bomberg*, The Tate Gallery, 1988

Arthur Dimmock, *Tommy: A Biography of the Distinguished Deaf Royal Painter A. R. Thomson* (1894–1979), Scottish Workshop Publications, 1992

Brian Foss, *War Paint: Art, War, State and Identity in Britain, 1939–1945*, Yale University Press, 2007

Paul Francis, Richard Flagg, Graham Crisp, *Nine Thousand Miles of Concrete: A Review of Second World War Temporary Airfields in England*, Historic England, 2017

Martin Francis, *The Flyer: British Culture and the Royal Air Force 1939–1945*, Oxford University Press, 2008

Andy Friend, *Ravilious & Co: The Pattern of Friendship*, Thames & Hudson, 2017

Guy Gibson, *Enemy Coast Ahead*, Michael Joseph, 1946

Maeve Gilmore, *A World Away: A Memoir of Mervyn Peake*, Gollancz, 1970

Charles Hall, *Paul Nash: Aerial Creatures*, Lund Humphries, 1996

Meirion and Susie Harries, *The War Artists: British Official War Art of the Twentieth Century*, Michael Joseph, 1983

Tanya Harrod, *Humankind: Ruskin Spear: Class, Culture and Art in 20th Century Britain*, Thames & Hudson, 2022

Eric Kennington, *Pilots, Workers, Machines*, Frigidaire, 1941
© Eric Kennington Estate

Andrew Lambirth, *The Art of Richard Eurich*, Lund Humphries, 2020

Paul Nash, *Outline, An Autobiography and Other Writings*, Lund Humphries, 2016

Gerard Neill, 'Peake at the Imperial War Museum', *Peake Studies*, Vol 1, No 4, 1990

Eric Newton, *War Pictures at the National Gallery*, National Gallery, 1942

Vincent Orange, *Coningham: A Biography of Air Marshal Sir Arthur Coningham KCB, KBE, DSO, MC, DFC, AFC*, Methuen, 1990

Mervyn Peake, *The Glassblowers*, Eyre & Spottiswode, 1950
© The Estate of Mervyn Peake

Daphne Pearson, *In War and Peace: The Life and Times of Daphne Pearson, GC*, Thorogood, 2001

Tom Pocock, *1945: The Dawn Came Up Like Thunder*, Collins, 1983
© The Estate of Tom Pocock

Alan Powers, *Eric Ravilious: Artist and Designer*, Lund Humphries, 2013

William Rothenstein and Lord David Cecil, *Men of the RAF*, Oxford University Press, 1942

James Russell, *Ravilious in Pictures: The War Paintings*, The Mainstone Press, 2010

Rebecca Searle, *Art, Propaganda and Aerial Warfare in Britain during the Second World War*, Bloomsbury Publishing, 2020

Gordon Smith, *Mervyn Peake: A Personal Memoir*, Victor Gollancz, 1984

Sacha Llewellyn and Richard Sorrell (eds), *Alan Sorrell: the Life and Works of an English Neo-Romantic Artist*, Sansom and Co, 2013

Daniel Swift, *Bomber Country*, Hamish Hamilton, 2010

Peter Townsend, *Time and Chance: An Autobiography*, HarperCollins, 1978
© Rights Holder

Miles Tripp, *The Eighth Passenger: A Flight of Recollection and Discovery*, Heinemann, 1969

Harry Watt, *Don't Look at the Camera*, Elek, 1974
© Rights Holder

Francis Wheen, *The Soul of Indiscretion: Tom Driberg, Poet, Philanderer, Legislator and Outlaw*, Fourth Estate, 2001

Geoffrey Williams, *Flying Through Fire: FIDO – The Fog Buster of World War Two*, Sutton Publishing, 1995

G Peter Winnington, *Vast Alchemies: The Life and Work of Mervyn Peake*, Peter Owen Publishers, 2000

Archives (written)

War Artists Advisory Committee archive, IWM

Kenneth Clark papers, Tate Archive

Richard Eurich papers, Tate Archive

Paul Nash papers, Tate Archive

Mervyn Peake papers, British Library
© The Estate of Mervyn Peake

IWM Sound Archive

Richard Eurich (3818)

Julius Stafford-Baker (5398)

Rupert Shephard (3198)

Willoughby de Broke (5195)

Wilhelm Mohr (26590)

Films

Transatlantic Airport, Crown Film Unit (1944) (IWM, CVN 227)

Target for Tonight, Crown Film Unit (1941) (IWM, ADM 210)

Journey Together, RAF Film Production Unit (1944) (IWM, APY 26)

Out of Chaos (1944), dir. Jill Craigie, British Film Institute

Acknowledgements

Many people have helped me with this book and I would like to thank: the late Robin Lenman; Julia Sorrell; Philippa Eurich; Caroline Moser; Harry Raffal and Julia Beaumont-Jones, the Royal Air Force Museum; Francis Hanford, the Trenchard Museum; Fiona Campkin; Marissa Sonnis Bell; the staff of the British Library; IWM colleagues Rebecca Newell, Paris Agar, Claire Brenard, Anthony Richards, Lara Bateman, David Fenton, Madeleine James, and the staff of the IWM Research Room; former colleagues Angela Weight, Roger Smither and Ruth Findlay; Diya Gupta; Julian Hills; Oliver Carter-Wakefield; Jane McArthur; Neil Herrington; Helen Day and Mary Horlock.

Suzanne Bardgett was Head of Research and Academic Partnerships at IWM from 2010 to 2023. Her first book about IWM's art collection was *Wartime London in Paintings* (2020). She is now a freelance author and editor.

Praise for *The Air War in Paintings*

Elegantly written and lavishly illustrated – a gripping study of art and war by one of the UK's experts.

Joanna Bourke, Professor Emerita of History, Birkbeck, University of London

In the Second World War few combatant nations devoted as much material and human resources to the war in the air as the British. With every aspect of the nation's war effort linked to aviation, it was a subject with a huge profile in wartime discourse. Suzanne Bardgett's fascinating exploration of the visual representation of the air war reveals the depth and breadth of the images created, under official sponsorship, and how they have become iconic of a nation in the midst of total war.

Mark Connelly, Professor of Modern History, University of Kent

Suzanne Bardgett has assembled a beautifully reproduced and presented array of paintings dedicated to Britain's war in the air. Her astute choice of paintings (accompanied by an authoritative commentary) encompasses not just flyboy glamour, but the more mundane material and human infrastructure of airfields and workshops that sustained them. Particularly commendable in this expertly-curated selection is the significant presence of women, both as subjects and artists, while all the paintings allow us a unique access to the intimate and quotidian dimension to total war.

Martin Francis, Professor of War and History, University of Sussex

The Air War was conducted in the sky, but also in many less predictable places – aircraft hangars, factories, hospitals and even in the Empire Ballroom, Blackpool. The official war artists captured the technology of flight, the drama of action and the human stories of dogged resilience in adverse conditions that war brings. Suzanne Bardgett has brought together a wonderful array of different artists – some famous and others virtually unknown – that makes not only a revealing narrative of these crucial years but a conspectus of artistic styles showing observational but emotionally engaged painting as it developed in the mid-twentieth century.

Alan Powers, writer on mid-twentieth-century art and design